Painting Landscapes in Oils

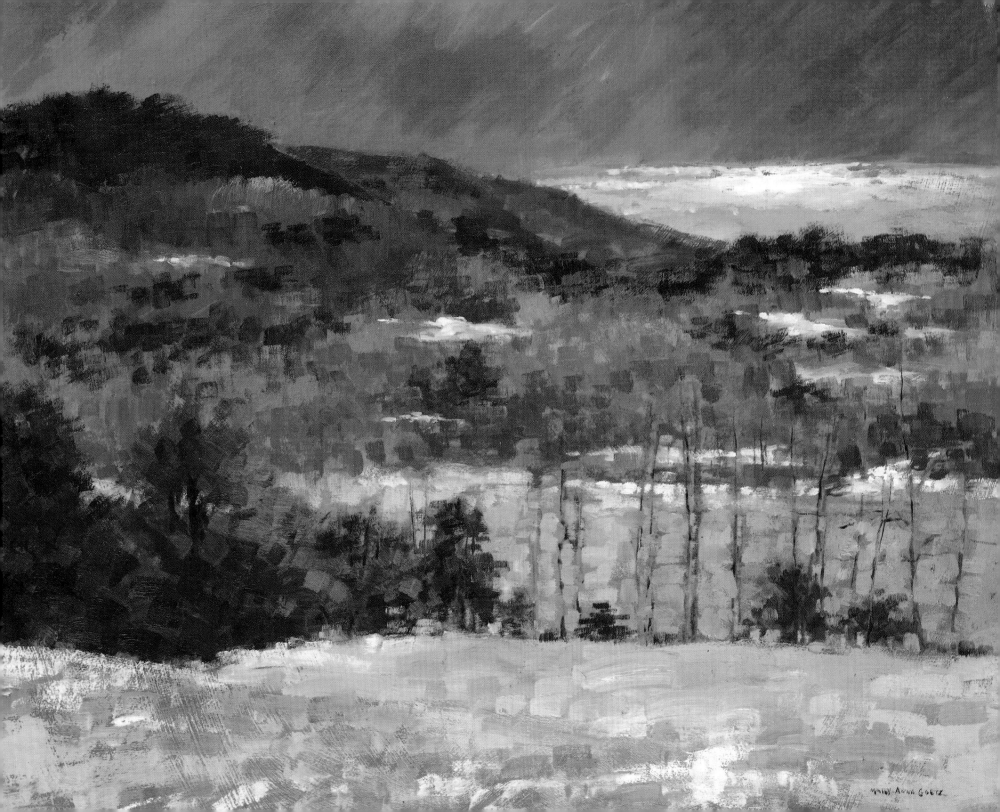

PAINTING LANDSCAPES IN OILS

MARY ANNA GOETZ

NORTH LIGHT BOOKS

Cincinnati, Ohio

Painting Landscapes in Oils. Copyright © 1991 by Mary Anna Goetz.
Printed and bound in Hong Kong. All rights reserved. No part of this book
may be reproduced in any form or by any electronic or mechanical means
including information storage and retrieval systems without permission in
writing from the publisher, except by a reviewer, who may quote brief
passages in a review. Published by North Light Books, an imprint of F&W
Publications, Inc., 1507 Dana Avenue, Cincinnati, Ohio 45207. First edition.

95 94 93 92 91 5 4 3 2 1

Library of Congress Cataloging in Publication Data

Goetz, Mary Anna
 Painting landscapes in oils / Mary Anna Goetz.
 p. cm.
 Includes index.
 ISBN 0-89134-377-6
 1. Landscape painting–Technique. I. Title.
ND1342.G64 1991
751.45 ' 436–dc20 91-13519
 CIP

Art facing Title Page: VIEW FROM COOPER LAKE ROAD
Art facing Table of Contents: MAGIC MEADOW

DEDICATED TO

my husband,
my father
and my children
in loving memory of my mother

———————

ACKNOWLEDGMENTS

The first people I would like to thank are those to whom I have dedicated this book.

My husband, Jim Cox, has been a daily source of inspiration and support. My father, Richard Goetz, taught me almost everything I know about painting. My children, Nathan and Julianna, patiently endured "Mom's book." My late mother, Edith Goetz, also a painter and teacher, showed me that a successful artist can also be a good mother.

I would also like to thank Henry Hensche, whose classes were a tremendous aid in my understanding of light and color.

Thanks also to Grand Central Art Galleries, Newman Galleries and all the collectors, corporations and institutions who so graciously cooperated in my effort to include my best work in this book.

I am most grateful to everyone at North Light Books, especially David Lewis, editor Mary Cropper and designer Carol Buchanan.

Finally, this book might never have come about without editor Bonnie Silverstein, who introduced my work to North Light.

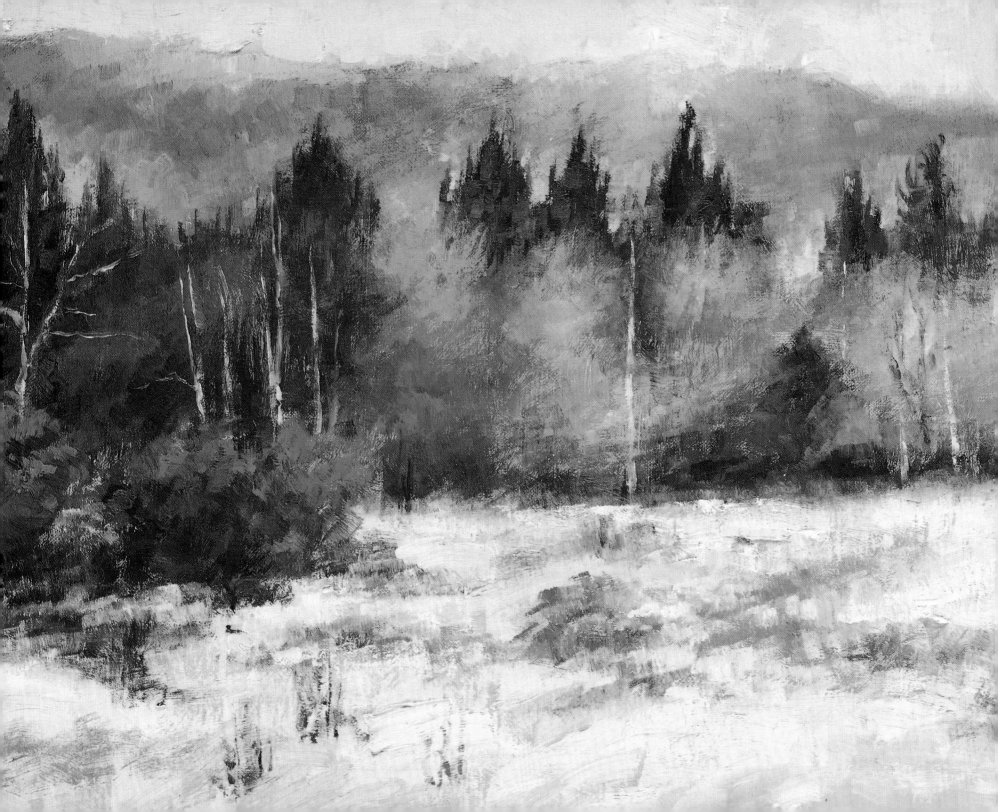

MARY ANNA GOETZ

CONTENTS

PREFACE

Since my parents were both painters, I have been surrounded by art since I was born. Step into the kitchen of my childhood home in Oklahoma and you would have encountered a raucous circle of artists and students sitting around the table—a big jug of wine in the middle. Open the refrigerator and you would have found rabbit skin glue and palettes of oil paint. My father's studio occupied the living room, my mother's the second floor. It was difficult to negotiate the hallways because they were lined with picture frames. We didn't have a Ping-Pong table in the basement. Instead we had a frame-carving machine invented by my father. Every inch of wall space in our house—from the baseboards to the ceilings—was covered with artwork—etchings, oil paintings, watercolors, drawings, prints and pastels.

Out of six children, three became professional artists. My sister Susan specializes in portraits and still life and is married to artist Robert Schneider. My brother George is a landscape painter. The other three, who chose different paths, are also involved in the arts. My brother Bill is a Santa Fe cabinet and furniture maker and paints landscapes when he gets a chance. My sister Virginia plays Mozart beautifully—usually with three kids running around the piano. She also sells and collects antiques and makes pottery. My brother Victor plays the bass guitar in a rock band and performs in Texas and Oklahoma. To top it all off, I married an art dealer.

Teaching has also played an important role in the artistic life of my family. My parents operated their own art schools for twenty-five years and my father is now on the faculty of the Art Students League in New York. All of us who have chosen painting as a career teach private classes and workshops. (I recently began teaching at the Woodstock School of Art.)

In our new home in Woodstock, New York, I continue to find myself surrounded by artistic influences. For seventy years, this famous art colony has been a haven for landscape painters who work from nature. Surrounded by the Catskill Mountains, Woodstock attracts hundreds of artists and students who come for its natural beauty and the inspiring character of its inhabitants.

This lifelong exposure to the world of painting and teaching was a great help in writing this book. I hope that the advantages I have enjoyed—growing up in an atmosphere where painting was the subject of the day—every day—have made my thoughts instructive and easy to grasp.

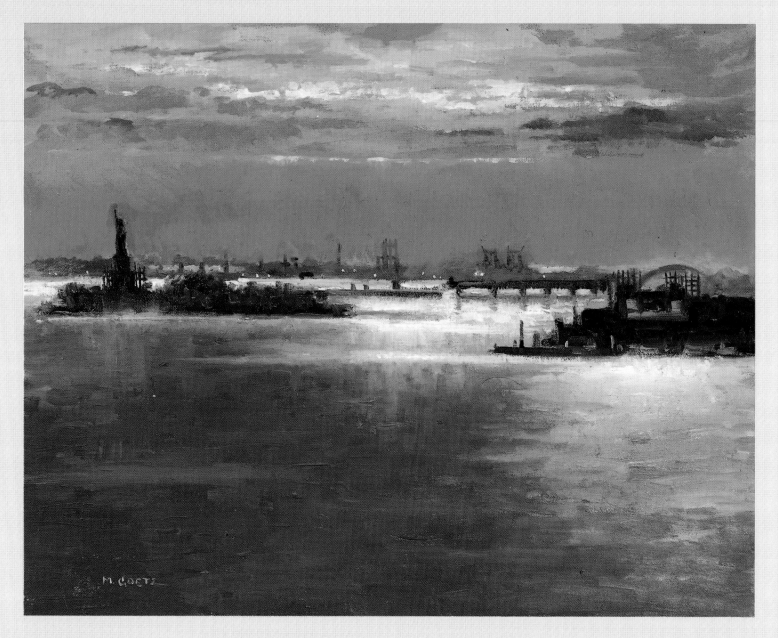

STATUE OF LIBERTY AT SUNSET (20x24) Private collection.

PAINT WHAT YOU SEE

This is an exciting time to be a painter because no one style dominates the art scene. Today an artist can use a number of devices to record what he or she wants to say. Academic theories, observation of nature, imagination, abstraction and photography are all valid tools. My own work has been most influenced by the second of these examples—observation of nature.

I try to paint what I see, not what I know is there. I don't rely on a formula for making shadows or creating a sunny light. Instead I ask myself, "What color of green is the shadow side of the tree in this light? Is the sunny afternoon sky casting an orange, yellow or pink light on the light side of the trees?"

What I am referring to here is the difference between the *local* color of the subject—the color we know it is—and the *affected* color—the color created under the prevailing light conditions.

It helps to begin by making a *grisaille* (a preliminary, one-color value painting; see pages 17 and 50-51). By solving value problems early on, you are free to concentrate all your attention on light and its impact on the color of what you are painting.

When I begin to apply color to the grisaille, I think in terms of comparisons. What color is the white barn compared to the trees behind it? What color is the light side of the tree compared to the shadow side?

This idea is difficult to grasp at first. We *know* the trees are green and the barn is white. Again, concentrate on what you really see. It helps to exaggerate the affected color. If the trees look a little orange on the light side, go ahead and make the light side orange. Then refine that first statement by working in a little of the local color. You will probably be surprised how orange the light side of the tree really is. More important, the orange statement will express the light much more convincingly than a mixture of white and green.

BOATHOUSE IN CENTRAL PARK

(20x30) Collection of Mr. & Mrs. Fred Ross.

This painting illustrates how the color of a subject is affected by light conditions as well as the elements surrounding it.

The stunning color of the weathered copper roof on the boathouse was much more emphatic on a gray day than it would have been on a bright sunny one. Bathed in sunlight the roof would have been very yellow—more in the same color range as the green trees beside it. Under gray light the turquoise patina of the roof was more evident.

The mass of trees behind the building also enhanced the bright color of the roof. Against a background of warm green the roof was a shimmering cool note. Eliminate the foliage and imagine the building set against a pale gray sky. The impact of the color of the roof would be much less dramatic.

Once I established the contrast between these major elements, I needed to "open up" the composition. The trees were too dense. I therefore designed openings in the trees that broke up this big dark mass.

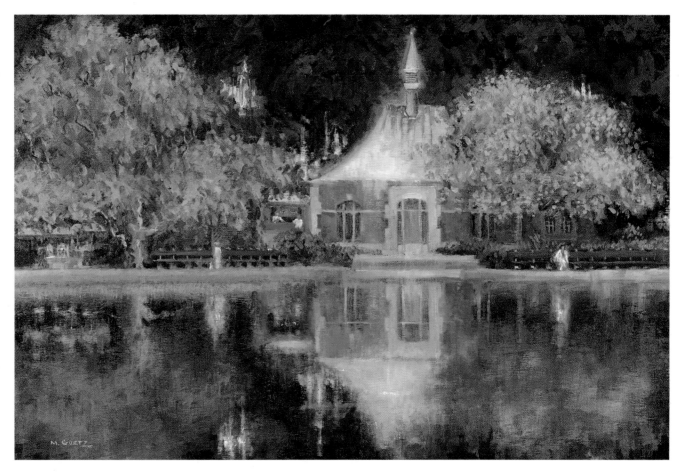

ELLIS ISLAND, LATE AFTERNOON

(16x20) Private collection.
In this painting, I've ignored detail and relied on illusion and color to create an impression of the moment. The sun was low enough on the horizon to include in this otherwise simple composition.

Late on a summer afternoon the natural light, combined with the airborne pollution that hovers over New York Harbor, create a pink hazy light. The sky and water are almost the same color.

I relied on technique to make this simple idea more interesting. I applied a lot of paint *a la prima* (in one pass)—you can see the brushstrokes clearly—which resulted in a loose, buttery texture, similar to the French Impressionists' style. The colors and technique combine to give the scene a magical quality.

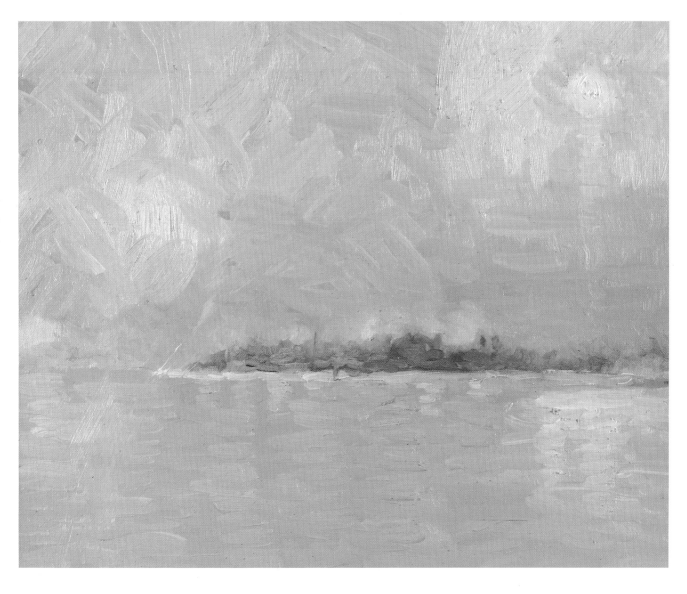

LIGHT

Understanding the light conditions under which you'll be working is vital for a visual painter. If you want to capture just what you see instead of what you logically know is there, begin by analyzing the one ingredient that most affects your subject—the light.

I can't give you a formula for painting a cloudy afternoon. I can't tell you to mix Indian yellow and white to express the light side of a tree. If you want to describe what you really see, your own eye is your most valuable tool.

Understanding the intensity of the light is a good first step. Are you dealing with bright sunshine that creates brilliant lights and deep shadows? Or is a cloud cover subduing the contrast between light and shadow? Is early morning haze filtering the sunlight and softening the edges in the composition?

Remember that the quality and character of light changes the subject constantly. Often a scene makes a beautiful subject under the haze of a morning light, but is dull and less interesting later in the day.

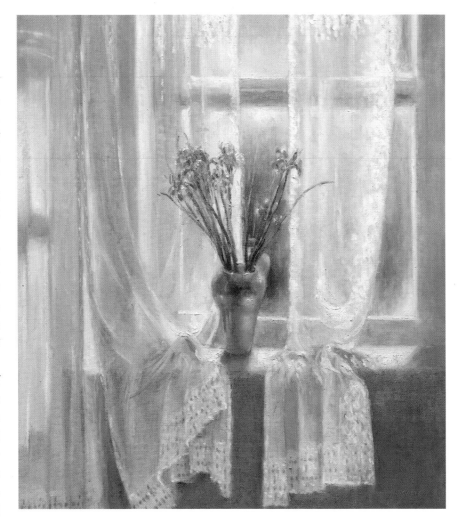

IRIS

(34x30) Collection of Mr. & Mrs. David Balinsky.

I wanted to keep this composition very simple, focusing my attention on the sunlight pouring through the sheer curtains. The light changed constantly, especially the patch of sunlight on the windowsill. Once I decided how I wanted to design the sun spots, I worked with that arrangement, instead of constantly altering the design every time the light changed. The affected color of the walls was violet, while the direct sunlight created a hot yellow light pattern. Working a little yellow ochre into the purple wall kept it from looking too cool.

Detail from IRIS.

If I had painted the light shining through the sheer curtain using pure white paint these spots would have looked like part of the pattern on the fabric. The golden yellow color of the sunlight helps the viewer understand what I was trying to describe.

Detail can also destroy the feeling of light. Modeling too much of the lacy pattern in the curtain would have been distracting. I therefore indicated a little of the lacework on the portion of the curtain that was draped over the windowsill. Direct sunlight pouring through the window softened all the edges in the composition. Building up too much texture would have dispelled the light, airy feeling I was after. To refine my initial color statements, I therefore used a drybrush technique, making subtle changes.

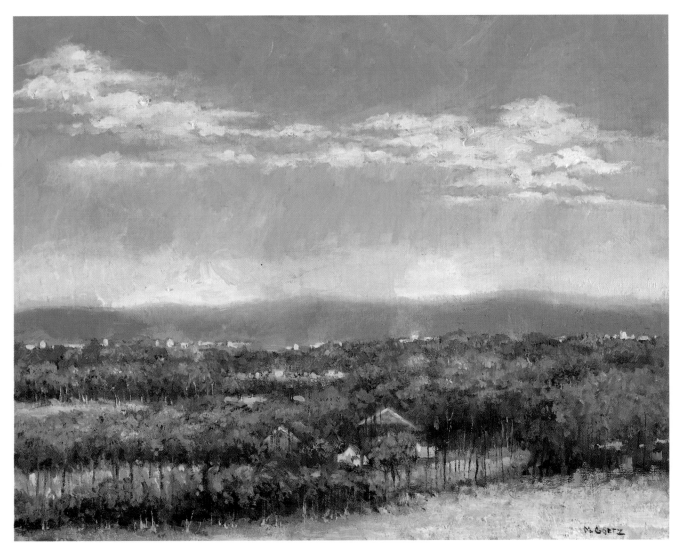

BUCKS COUNTY AND NORTH

(16x24) Collection of Frank Giordano. This view was painted on a bright February afternoon with such a vibrant blue sky the light conditions were very cool. In the clear, luminous winter light, buildings in the distance glistened—everything seemed to shine. It was important to carefully orchestrate these bright notes. Otherwise they would have been so distracting the viewer wouldn't know where to look first.

If I had painted the buildings and sun-streaked areas using pure white paint these elements would have looked confusing and "pasted on." The yellow color created by the bright winter sun helped verify the fact that these were sunbathed buildings and patches of grass.

On a sunny winter day the light is so cool and the scene so clear it's difficult to establish a sense of distance. In a panoramic mountain view like this it is important to create the illusion that everything recedes. I therefore exaggerated the bluish affected color of the mountains. This overstatement helped clarify the expansive character of this landscape.

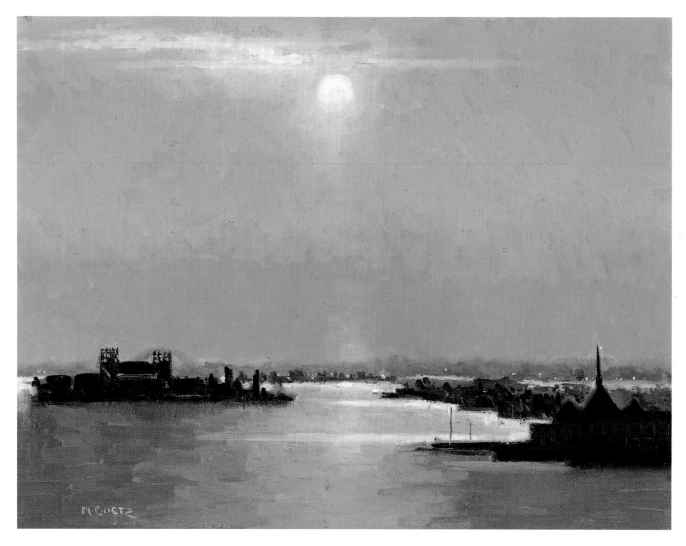

ELLIS ISLAND AT SUNSET

(16x20) McCarter & English, Princeton, New Jersey.

When the sun is low in the sky it is often shining directly in your eyes, blurring everything around it. A little fog or cloud cover can reduce the glare enough to allow you to include the actual light source in the composition. I had this opportunity while painting New York Harbor from a high rise apartment building.

The setting sun backlighted Ellis Island and the other structures in the harbor while obliterating most of the detail. The illuminated inlets helped create a design that leads the eye around these dark passages and through the painting. I subtly repeated this pattern in the water mass in the foreground.

Notice how warm the shadows are. A painting formula might have told me to keep the shadow cool and the lights warm. But on this day the setting sun added a rich warmth to every aspect of the scene, including the shadows.

This painting was done while Ellis Island was being restored. You can see that the building is shrouded in scaffolding.

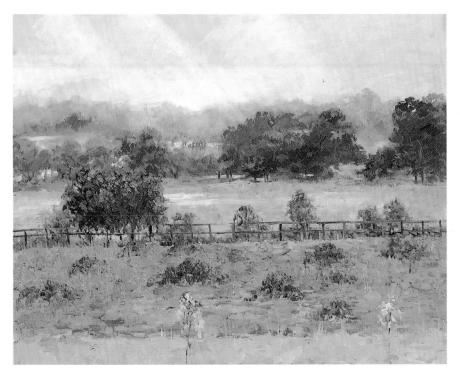

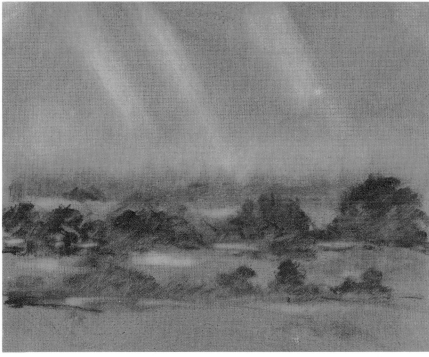

LATE AFTERNOON IN MICHIGAN

(24x30)

Compare this painting, done on a humid summer afternoon, to *Bucks County and North* (page 15). In the winter scene the light is cool and crisp, there is very little atmosphere and the local color is more evident.

In this summer painting the light is very warm. Light filtering through the humid atmosphere softens the entire scene. Even though this is a summer painting and the trees and foliage were actually dull and green, the bright sunlight warmed all the colors in these areas.

The difference in light conditions and time of day account for the contrast between these two paintings. The winter light was cool and clear while the summer light was warm and hazy. *Bucks County and North* was done in the middle of the afternoon, while *Late Afternoon in Michigan* was painted late in the day, when the sky is just beginning to turn yellow.

The humid haze that surrounded the trees in the background also enhanced the feeling that everything was washed in warm light. Bands of hot white light emerging through the trees in the middle distance helped establish this area as the focal point of the painting.

Grisaille for LATE AFTERNOON IN MICHIGAN.

In this painting the white shafts of light helped lend more drama to an otherwise flat, hazy summer sky. When adding this type of effect, be careful to keep the shafts of light at identical angles. It is trickier than you may think. I usually block them in on location then refine them in the studio. It is also important not to go overboard. Keep these shafts of light as subtle as possible, while still taking advantage of their dramatic quality.

I began this painting by applying a grisaille. Using a burnt sienna tone I stained the entire paint surface before laying in my composition. I began by blocking in the main dark masses—the hills and trees in the distance, and the patterns of grass and bushes in the foreground. Using a rag I then wiped out the light areas.

I usually begin by wiping out the light mass of sky. I was careful not to wipe out too much in this area because the passage of light shining through the trees was to be the brightest note in the composition. The same things apply to the shafts of light. I didn't want them to overwhelm the focal point in the middle distance.

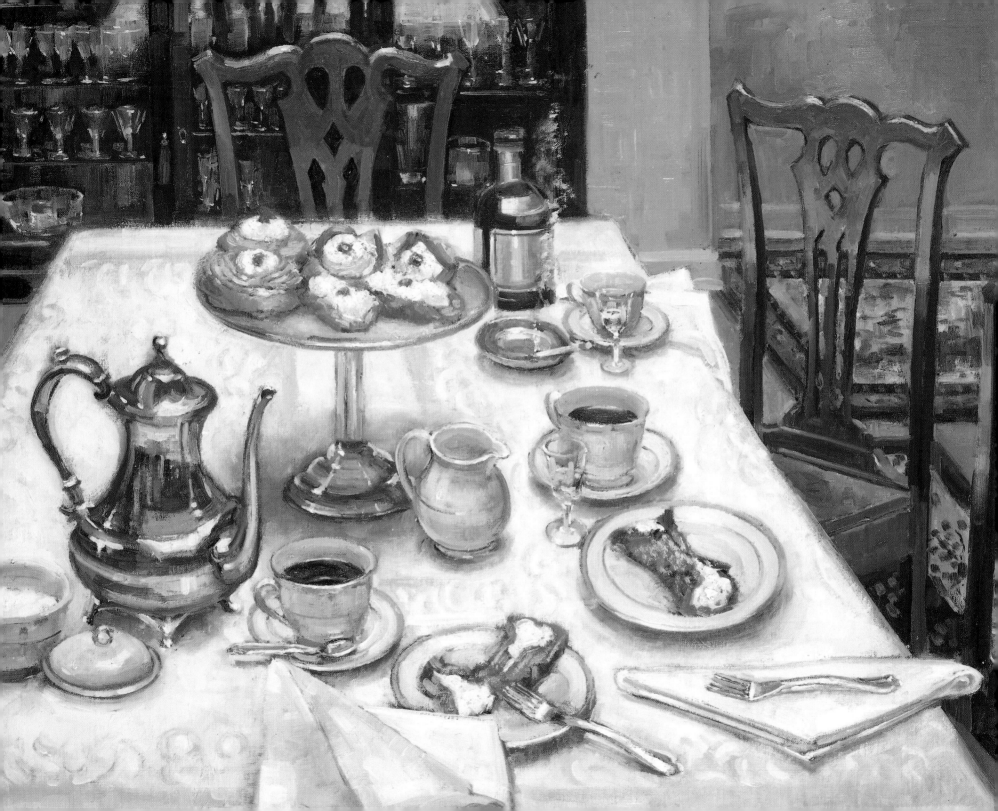

NAME YOUR POISON

(24x30) Courtesy of Grand Central Art Galleries, New York.

I wanted to convey a definite theme in this painting, depicting pleasures that fell out of favor in the 1980's: sweets, coffee, liquor and cigarettes. I felt that portraying these "poisons" in elegant surroundings lent more impact to the idea.

I used no interior lighting, working instead with the soft, gray light from the skylight overhead. In this full light the shadows were soft. It was the sparkling quality of the silver and crystal that produced a gleaming light effect, rather than dramatic light and shadow patterns.

Since this arrangement was complicated I tried to simplify things when possible. I composed the objects on the table to draw the eye toward the cakes and silver coffeepot. I eliminated as much detail as possible in the china cabinet and objects in the back of the table. I didn't want them to jump forward.

I used the same technique with the damask tablecloth, merely suggesting the linen pattern. Adding too much fussy detail is always a mistake. In a composition like this one it was especially important to understate all the intricate patterns and detail.

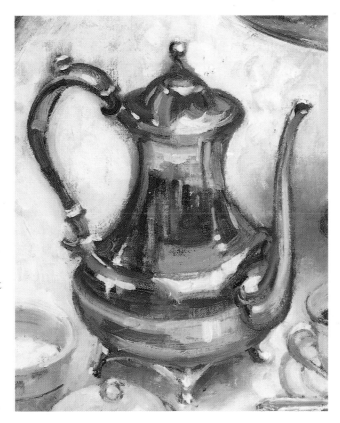

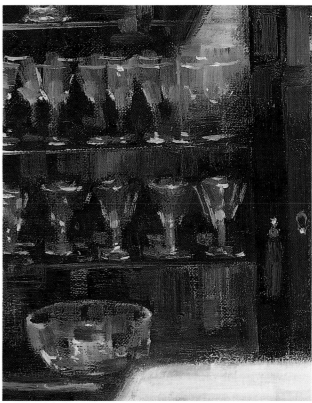

Detail from NAME YOUR POISON.
I liked the picture within a picture created by the reflections in the coffeepot. Reflections, however, are very tricky to paint. It's easy to make them too light and detailed. You don't want them to destroy the dark mass they're a part of. To keep the reflections from jumping forward I blocked them in as abstract patterns when I applied my grisaille. I refined them once I began to work in color, but still kept them loose and sketchy. The viewer can fill in the details because he can see the objects that are being reflected.

Detail from NAME YOUR POISON.
I wanted to capture the sparkling light on the stemware and crystal inside the china cabinet. However, all of these exciting details had to be kept in the background. I didn't want this area to dominate everything else. I laid the glassware in using flat brushes and broad strokes. I then drybrushed over this area several times, using a mixture of raw umber and white. This was like putting a thin veil over the intricate background. The drybrush work subdued the shiny glasses without destroying what they added to the overall idea.

Color and Value

Just as a more academic painter studies the light effect in terms of value (how light or dark a mass is), I think in terms of color.

That doesn't mean that value is no longer important. Without a proper balance between light and shadow the light effect will be lost. However, if the color is right the value will be right.

I mentioned before that I always apply a grisaille first so I have established the value range in the composition before working in color. By beginning this way I force myself *not* to think in terms of how light or dark a color mass is—I've already figured that out in the beginning stage. I focus my attention instead on color.

Once you have trained yourself to really see color, subjects you never dreamed of painting become more compelling. Stands of bare trees in winter are an excellent example. They appear just as beautiful as they do in spring once you discover all the muted hues of amber, mauve and gold evident in pearly winter light. Try to see beyond the obvious. The artist's job is to reveal more than meets the casual observer's eye.

It is helpful to study affected color and value contrasts in a simple indoor still life. Here you can control the light and won't have to contend with the constant light changes and numerous distractions found outdoors.

Moreover, it is easier to see the light and shadow side of an apple than to detect value contrasts in a clump of trees. It is also easier to study the affected color in a few simple objects. Outdoors you will be faced with so many different elements it will be difficult to concentrate on the basics.

You might also try an outdoor still life which will help you adjust to the intensity of outdoor light.

Don't be afraid to overstate the affected color, even if the results are garish. Once you have refined your eye, it won't be necessary to make such bold exaggerations.

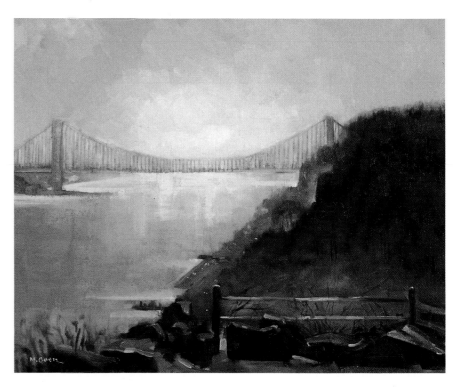

Rockefeller Lookout

(16x20) Courtesy of Grand Central Art Galleries, New York.
There was very little bright color in this winter view of the Hudson River, making this composition a good study in value contrasts. The dark grassy mound and boulders in the foreground represent one end of the value scale, while the burst of light behind the George Washington Bridge represents the other end. The even color of the sky and water describes the middle value.

To compensate for the lack of a wide color range, I exaggerated what I had to work with. I made the light behind the bridge a bit yellower and more brilliant than it really was. To break up the dark mass of the hill I enhanced the light on the rail in the foreground. I also carefully studied the affected color. For example, the sky and water weren't a dull gray. Both were pink in the foggy autumn light.

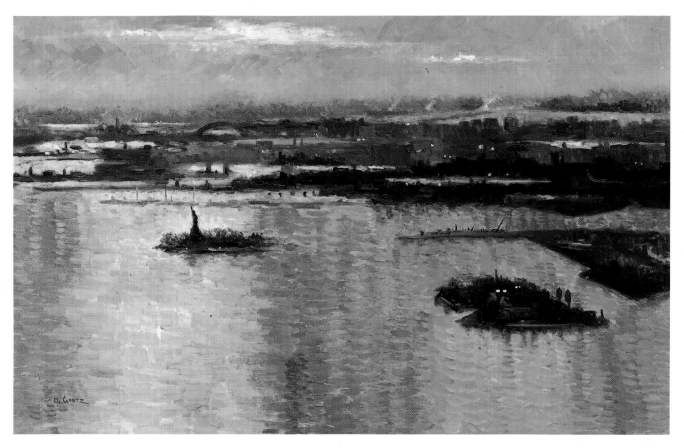

NEW YORK HARBOR

(20x30) Private collection.
Although I had painted New York harbor from ground level many times, I found this scene even more breathtaking from an elevated vantage point. On a cloudy winter day, late afternoon sun shed a column of light across the water. Inlets off in the distance looked like silver ribbons while tiny spots of reflected light added interest to what might otherwise have been a rather static composition. Liberty Island, Ellis Island, and the Port of New Jersey also cut interesting patterns along the expanse of water.

The center of interest in this painting is the upper half of the format. The Statue of Liberty silhouetted against a strip of light helped establish this as the focal point of the picture.

The expanse of water in the foreground needed careful attention. It could have looked flat and boring had I not studied all the variations in the color of this wide mass.

I used short strokes of color in the water. This technique allowed me to record all the color variations without smearing everything together into one gray mass. The eye automatically blends these strokes so the overall color is evident as well as the subtle color changes.

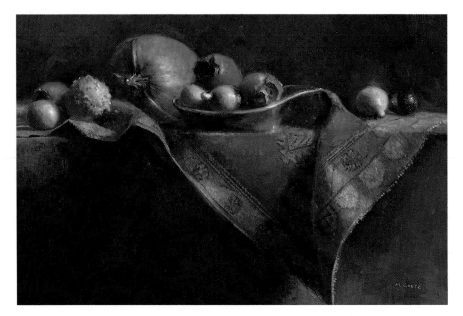

VIEW FROM CHASE MANHATTAN PLAZA

(24x20) Collection of Mr. & Mrs. Eric Sharf.
In this painting I was faced with such a sea of brick
and windows it was tempting to abandon the project altogether. It was especially helpful to view the
problem as an impressionist. I knew my composition included thousands of buildings and windows.
But is this what I really saw in this sweeping view of
Manhattan? Is all the intricate detail what attracted
me to this idea in the first place? No. The sunlight
bouncing off *some* of the windows and the lighter
buildings lent a jewel-like quality to the urban
expanse. It was the effect of the sunlight shining
on them, rather than the buildings themselves that
made this an appealing subject.

AUTUMN STILL LIFE

(18x24) Courtesy of Driscoll Galleries, Vermillion, South Dakota.
Setting up a still life indoors is a good way to study the light effect. You can
control the light and you won't have distracting weather conditions to contend with as you would painting a landscape.

In this arrangement the light was coming from one source, creating clear
light and shadow patterns. It is easy to see the light side, the highlights, middle values, shadows and cast shadows from the gourds and vegetables.

The same thing occurs outdoors. The light will be coming from one
source—the sun. One side of the tree will face the light, while certain leaves
on the light side catch more sun, similar to the highlight on an apple. A
middle value will occur between the light and shadow sides. The tree itself
will create cast shadows on the ground beneath it. All of this is easier to see
and understand if you work in a controlled indoor situation first.

Detail from AUTUMN STILL LIFE.

The shadows in this painting are flatter and more transparent than the light side of the objects. I built up more texture in the lights, pulling them forward, while the more somber notes receded. Notice that I haven't mixed one "shadow color" and used that in all the darks. Each shadow is handled differently—as a separate mass of color.

MOOD AND ATMOSPHERE

Light and color are the vital ingredients in visual painting. But to transform a study of light and color into a finished painting, it is also important to consider mood and atmosphere. Conveying a sense of place and time will lend more interest and emotional appeal to your subject.

Sometimes the light itself will create a mood. For example, the sky in a dramatic sunset painting places the viewer in a particular time frame. Light filtering through early morning mist has the same effect. A time, a place, a mood have all been established.

Elements in the composition can work the same way. A strip of new spring grass, patches of snow or a bed of flowers can add just the atmospheric touch an otherwise dull subject needs.

The two paintings on page 25 illustrate my point. The snow on the ground in *Bucks County Woodlot* added interest to the view, while establishing a sense of time—late winter. The hazy morning light in *Fifth Avenue* added an ethereal quality to this otherwise modern, urban motif.

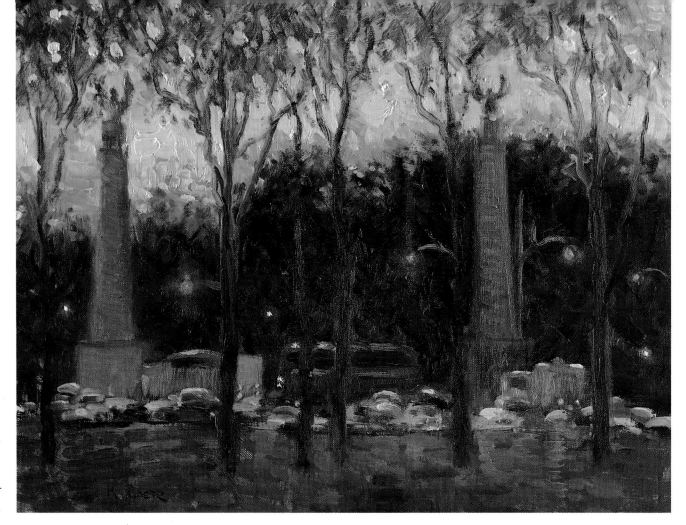

GRAND ARMY PLAZA
(11x14) Private collection.

I painted this at twilight, just as the street lights were turned on. It was a perfect opportunity to create a specific mood. The combination of fading natural light and emerging street light evokes the feeling that the day is ending. The congested traffic circling the plaza also conveys the idea this is rush hour on a winter evening.

The sun had almost set, creating a halo of yellow around the tree tops. In this light the trees, traffic circle and park in the foreground were backlit, casting everything in warm shades of burnt sienna and yellow ochre. To keep these dark areas from looking too flat and dense I used broken color and added some leaves to the patch of grass in the foreground.

Since it was dark it wasn't necessary to model every car. I concentrated instead on designing the car lights so they made an appealing pattern and left the impression that traffic was circling around. It also helped to include a number of white cars, silhouetted against the dark background.

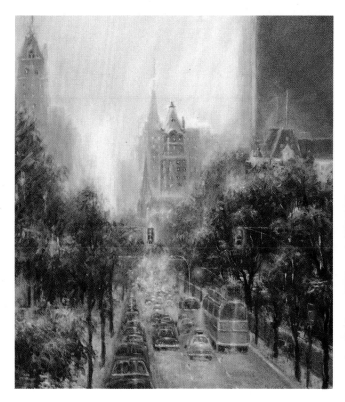

FIFTH AVENUE

(30x24) Collection of Mr. & Mrs. Ben Fishbein.

I wouldn't have composed this painting with the traffic as the center of interest had I not been working under hazy morning light. The car and traffic lights glowing in the yellow morning sunlight created an aesthetic mood. Under clear afternoon light the street packed with cars probably wouldn't have made a very appealing subject.

To take advantage of the effect created by dozens of lights receding into the distance I eliminated many of the cars and kept most of the traffic as abstract as possible. Making the cars in the foreground more detailed gave the viewer enough information to understand the subject, without ruining the beautiful abstract pattern created by the lights and atmospheric conditions.

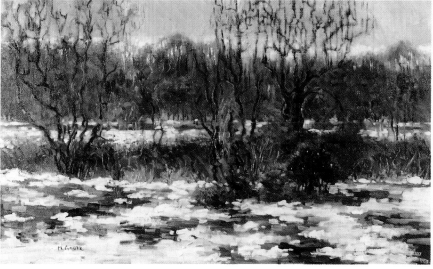

BUCKS COUNTY WOODLOT

(20x30) Collection of Rittenhouse Hotel, Philadelphia.

The striking combination of the green grass and patches of snow attracted me to this scene. The snow created a linear pattern that contrasted nicely with the vertical design of the bare tree branches.

I used a warm palette to convey the feeling this is a cloudy day in winter. (Bare trees are usually a warmer color than green foliage.) To warm the purple-gray sky, I used yellow ochre mixed with white. Working the ochre mixture into a wet paint surface I was able to warm the sky, without repainting it entirely. When trying to refine a blue or purple note with yellow, ochre is often a better choice than a bright yellow, which can make the refined statement too green.

WATERING THE ROSE GARDEN (20x24) Collection of Robert Coddington.

Deciding What to Paint

Success in choosing a good subject for a landscape depends on much more than finding a pretty spot to work. In studying a potential painting location, consider the subject in terms of how it will work in a painting, rather than how appealing it is visually. Is too much dense, green foliage obstructing the paintable elements in the scene? Is what you want to paint too far in the distance? Is the scene so picturesque it will appear trite in a painting?

Using a simple viewfinder will help immensely in making these decisions. (See pages 30-31 for how to use a viewfinder.) By framing what interests you with a viewfinder you can visualize how the subject will look as a painting, determine which aspect of the scene makes the best composition, and decide how to position the subject on the format you will be using.

Format is another important thing to keep in mind when choosing a subject. Would a small canvas diminish the impact of the subject? Would a large one destroy the intimacy of the scene? Would a horizontal or vertical format work best? Again, use a viewfinder. If possible bring along several canvases in various sizes.

Spending time experimenting with your viewfinder is the first step toward making unique compositions. Many factors can add interest to a landscape scene. Fields and meadows that create an unusual pattern, a dramatic sky, intriguing early morning or late evening light—all of these can help you avoid a trite or commonplace idea.

The sprinklers depicted in *Watering the Rose Garden* (facing page) transformed a "too pretty" scene into a more interesting idea and helped break up the expanse of green lawn. I composed the subject so the garden house was in the lefthand portion of the canvas, rather than in the middle, resulting in a more interesting arrangement.

One good location can also provide several painting possibilities. I have worked from the elevated promenade where I painted *Watering the Rose Garden* many times, working at different times of the day or year and building my composition around various sections of the same garden.

I want to stress that composing the idea in your head before you begin to work is as important as deciding what to paint. Study the location first, then make the most of what you see.

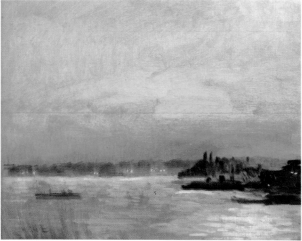

VIEW ACROSS THE HUDSON

(24x30) Courtesy of Newman Galleries, Philadelphia.

On this bitter cold day in mid-February, only the ground and rooftops of the buildings were still snowy. The bare trees in the foreground posed a problem because they cluttered this portion of the composition. I therefore eliminated many of them to make more snow visible. I then designed an interesting pattern with the buildings, roads and a railroad bridge near the water.

The warm brown foreground now contrasted nicely with the cool, blue background. The late afternoon sky created silver streaks in the river, and the town of Newburg, New York, sprawling along the foot of the hill, glittered in the winter light. I developed this passage as the focal point of my painting.

HOBOKEN SUNSET

(22x25)

Before beginning work on this sky-scape, I experimented with my view-finder to determine whether the sky or the shoreline and water should dominate the composition.

The sunset was so exquisite I decided to build my composition around this element, devoting four-fifths of the composition to the sky. Using big brushes and lots of medium I painted the sunset *a la prima* (in one pass). The shoreline and water were kept as simple, understated masses, so that nothing would diminish the impact of the sky.

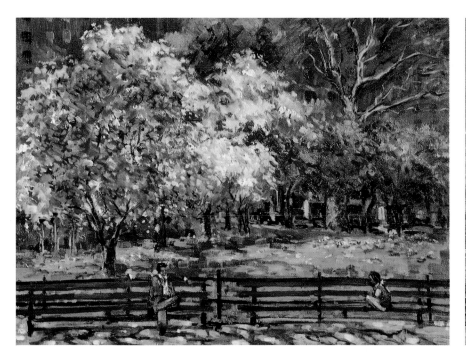

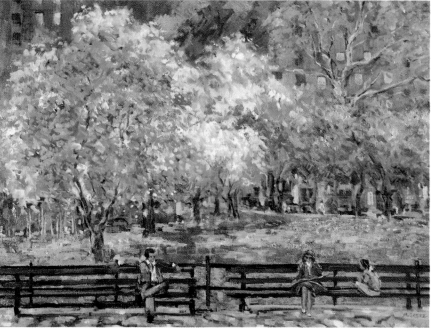

CITY HALL PARK IN SPRING—BEFORE
(18x24)

I began this painting on a sunny afternoon when the trees were in full bloom. It rained for several days after. By the time I returned, the rain had ended and most of the blossoms were gone. The only alternative was to finish the trees from memory in the studio.

CITY HALL PARK IN SPRING—AFTER
(18x24)

Once I began working indoors I noticed that the benches in the foreground were repetitive and uninteresting. Another figure was needed, so I introduced a woman reading the newspaper. Since the man on the left is bigger than the child on the right, the repetitive character of the park bench isn't as noticeable. Sometimes a small addition like this can correct a disturbing passage.

In the studio I also discovered a dead area in the top righthand corner of the painting, where the trees are light green. By adding blossoms in this area I was able to balance the brightly colored flowering trees on the left. I added even more interest to the background by emphasizing the buildings in the top lefthand corner. Notice that I have simply enhanced the existing lighted areas to bring them forward.

Once I was satisfied with the composition, I made one final change. I softened the entire painting, creating a more delicate spring look.

USING A VIEWFINDER

In the opening statement of this chapter I discussed some of the advantages of using a viewfinder. This simple tool is invaluable when deciding which size canvas to use and how to best compose a subject. I use a viewfinder made of two "L"-shaped pieces of cardboard, which can be adjusted to conform to any size canvas.

First use the viewfinder to frame possible subjects, moving it closer to or farther away from your eye to take in more or less subject area. While determining how much of the subject you want to include, also investigate which format is best—horizontal, vertical or perhaps even square.

Also use the viewfinder to establish a focal point. Without a center of interest in your painting your viewer will have no idea where to look first. Once the scene is framed it is easier to determine the most effective placement of the composition's key element.

If you can afford the time, devote your first trip to a painting site exclusively to experimenting with the viewfinder. Don't bring any other equipment along. When you arrive the next time to begin painting you will know exactly what size canvases to bring and how you want to begin.

Before you begin to paint, use the viewfinder to establish reference points. Hold a slim brush against the viewfinder at the horizontal and vertical centers of the opening. These reference points determine where key elements of the composition lie in relation to each other and to the overall picture. They also help you establish where the horizon line is in relation to the horizontal center of the painting. You can then decide whether you want the horizon line above or below the middle of the painting.

Reference points help head off compositional errors. Use them to make sure you haven't placed the dominant element smack in the middle or divided the canvas in an awkward way. Of course, all rules are made to be broken. But it is best to master the rules before trying something more innovative.

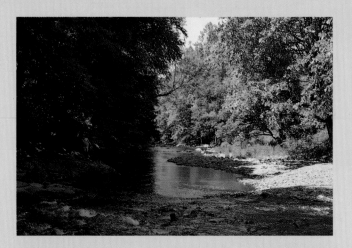

As you can see in the top picture, Calicoon Creek offered opportunities for many different compositions. I could have focused on the thick trees, the creek, the rapids in the foreground or the entire scene. I explored a horizontal version first (bottom), eliminating the sky and tightly closing in on the foliage and creek.

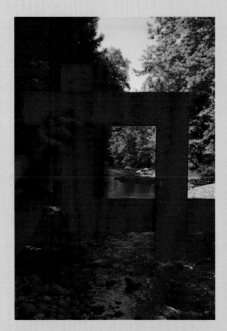

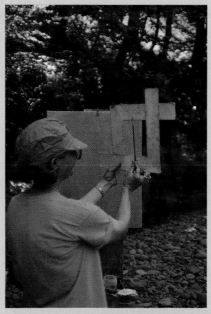

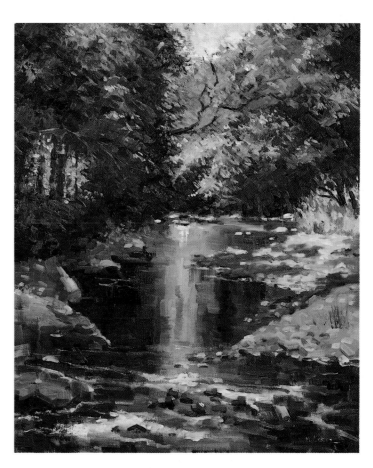

Next, I tried a vertical composition, again including just the creek and trees in my painting. (I always investigate several possible compositions and formats before I begin to paint.) I did choose this format, but I stepped farther back to include the rapids in the foreground and part of the sky.

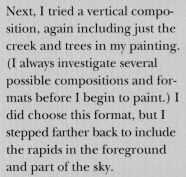

Here, I established reference points for my composition. As you can see, I held a slim brush against the viewfinder to determine which elements lay closest to the horizontal and vertical centers of the format. I then placed center markings before sketching in my composition (part of the *grisaille* painting procedure). This gave me a starting point. I also made sure I wasn't placing key elements in the middle. I wanted to create a balanced composition that made good use of the entire canvas.

CALICOON CREEK IN SUMMER
(24x20)
I was particularly drawn to the dramatic effect created by the reflection of the sky and sunlit trees in the water and the way the dark shadows surrounded it. I made this the focal point of my composition. Note the differences between this composition and my first version in the viewfinder. In the next chapter, I will explain in detail how I painted *Calicoon Creek in Summer* (see pages 46–49).

Two Paintings from One Scene

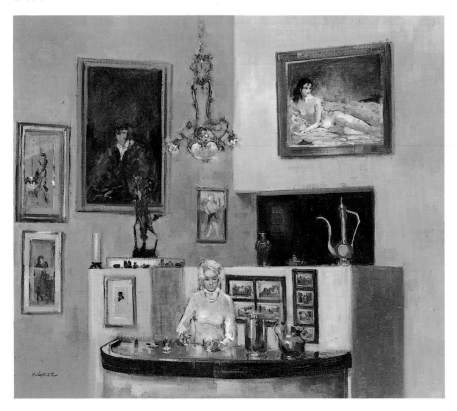

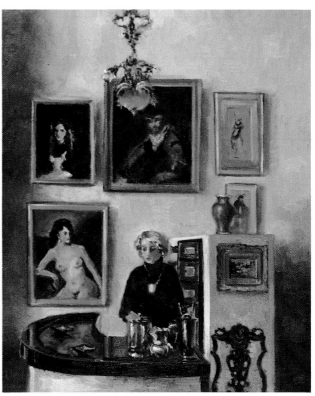

Janet at the Bar I

(34x36) Collection of Mrs. Janet LeClaire.

Interiors are a good alternative when it's impossible to work outside. Interior scenes can also provide an opportunity to develop several ideas at the same location.

These two paintings are part of a series of eight interiors of Robert Henri's studio. In this version I wanted to include the nude above the bar—one of Henri's finest. To take in this wall, I positioned myself in front of the north windows, facing the subject straight on. Janet and the bar were cast in full light, diminishing the light and shadow contrasts.

The north light made the objects on the sleek, contemporary bar gleam while Janet, dressed in yellow with silver blonde hair, complemented the limited color range. Almost everything else in the composition is black, silver or some variation of an earth color. I found that this uncluttered arrangement on a large format worked well.

Janet at the Bar II

(24x16)

I decided to do a second painting of Janet and the bar, but tried a new angle this time, positioning myself facing east. The sidelight, which exaggerated the shadows and keyed the value of the subject a bit lower than in the full-light version, created a more somber mood.

I wanted to make this a challenging composition, so I included some difficult elements. This painting depicts many objects arranged in a small area surrounded by little open space. To further reduce the negative space, I even hung another painting which added interest to a rather boring section of wall. I tried to include enough detail for a close-up view, without letting the detail overwhelm the rest of the composition.

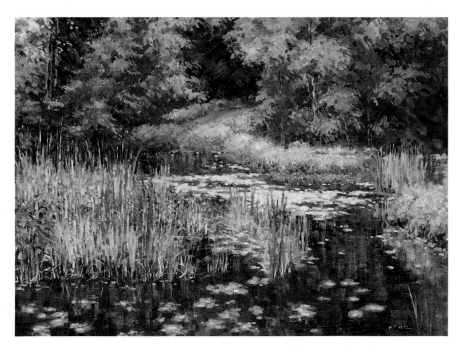

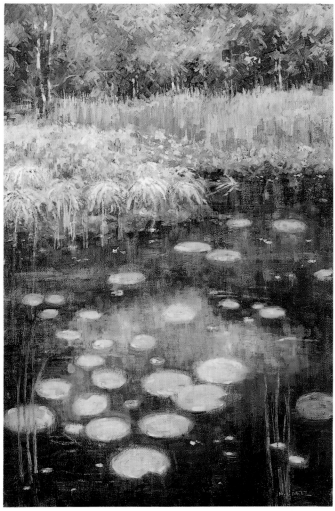

POND ON JAKETOWN ROAD
(30x40) Collection of Mrs. Elinor Driscoll.

These are two paintings of two different sections of the same lily pond. But that's not the only reason the two views look so different.

The most obvious difference is the change in format. In the painting above, the horizontal format creates a more expansive yet peaceful feeling that suggests an untouched, private place. The emphasis here is more on the setting—the trees and the edge of the pond are very important.

LILY POND
(30x20)

I chose a vertical format for the second painting to make the lily pads the focal point rather than capturing the entire scene. The pattern formed by the lily pads leads the eye through the painting to the early autumn foliage in the background. The lily pads in this section of the pond were a different variety, which helped in creating a new idea. In this later version the trees are also less verdant.

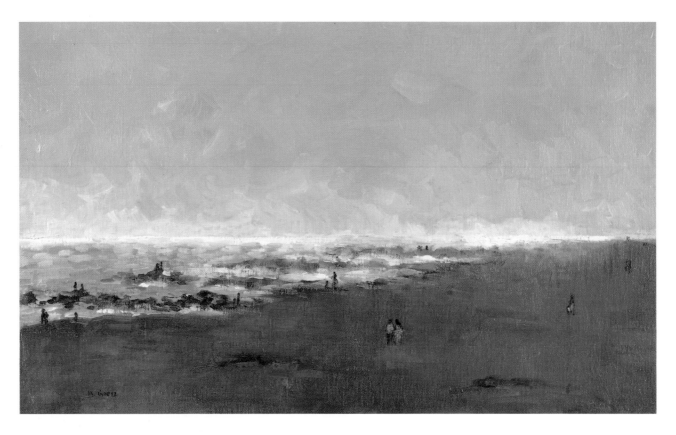

CONEY ISLAND BEACH

(20x30) Collection of Mr. & Mrs. Paul Kennedy.

Coney Island is no longer the bright, exciting playground it was in Reginald Marsh's day. Because the ocean isn't safe for swimming, few people spend their free time here. Imagine the same beach in the 1930s when thousands of New Yorkers flocked here to swim and sunbathe.

Knowing what a lively place this used to be added to the desolate feeling that prevailed on this autumn afternoon. The desolation was part of the aesthetic appeal of this subject.

I decided on a very simple arrangement, breaking the composition into three main masses—sky, ocean, and beach. I kept the beach flat, building up very little texture in this area. I used more paint in the water and kept the sky hazy and soft. The sparkling ocean is the focal point, while the big expanse of sky and beach adds to the empty, lonely character of the scene.

Capturing Your Impressions

Solving technical problems early on will free you to explore those aspects of a subject that intrigued you in the first place. Once you have decided on the right format and worked out a solid composition, reconsider what made this a compelling subject. Since I have been so influenced by the Impressionists, the light effect is usually what is uppermost in my mind. How is this bright sunshine or gray light affecting the color of the trees, the water, the sky and the foreground?

On a gray winter day the light is pearl-like and luminous. On a bright, sunny day the contrasts between light and shadow are much more pronounced. On a hazy day everything is bathed in a gauzy hue—what Monet called the "envelope of light."

Analyze the light conditions. Is this light cool or warm? Hazy or brilliant? Don't rely on what you think you know but on what you actually see. The green foliage will not be the same color on a sunny day as on a cloudy one.

Bright, sunny light is a good example. You would think all that sunshine produces a very warm light. However, bright sunshine is usually accompanied by a blue sky, which throws everything in a much cooler light. Your subject will actually look much warmer on an overcast day, though the light and shadow contrasts won't be as evident.

Once you have determined what kind of light you're dealing with, decide what technical approach will best describe what you see. A simple scene like *Hoboken Sunset* (see page 28) can be completed *a la prima*, adding just a few finishing touches in the studio. Overworking a subject like this would destroy the spontaneity of the sun-streaked sky. A more complicated subject may require many trips to the location and a more controlled technique. Sometimes even an involved subject can be successfully handled in a loose style that expresses only the basics.

Regardless of which technical approach I feel best suits a particular subject, viewing it in terms of light and color is my main concern.

Detail from Coney Island Beach. Glazing lightly over the underpainting on the beach gives that area very little texture. The flatness leads the eye toward the light on the water. The contrast between the very textured water and the flat beach reinforces the eye's movement toward that focal point.

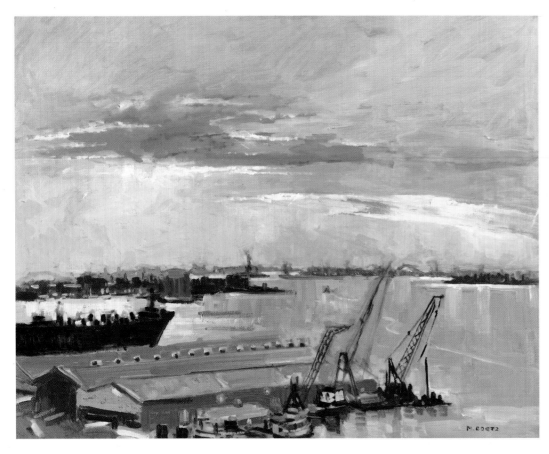

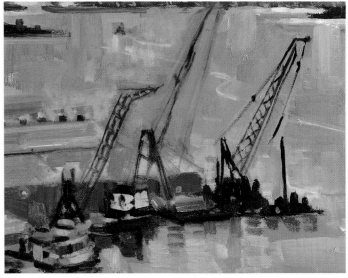

HARBOR AT SUNSET

(24x30) Courtesy of Grand Central Galleries, New York.

From several nice views of the harbor, I chose this one to capture the sunset. I started to paint about 4:00 P.M., just as a cloud moved in front of the sun creating rich, warm colors.

Sunsets are always difficult to paint because the light and cloud formations change from moment to moment. The snowy roofs and the cranes in the foreground added further complications. I knew the snow might melt by the next day (which it did) and that the cranes wouldn't be in the same position when I returned. I made a grisaille, concentrating on getting an accurate drawing of the cranes. I applied color only to the snowy roofs that first day. The light changed and I had to quit.

Detail from HARBOR AT SUNSET.

I included the cranes with the foreground buildings to add a new element to a familiar scene. This would be a painting of the working harbor instead of a more ethereal concept of water and the setting sun. I added the boat and the suggestion of its wake to lend even more animation to the scene.

Although I originally intended to make a much more finished painting, I found I had said all that I needed after two days of painting. Knowing when to stop is very important. I didn't want to risk overworking the painting and losing the spontaneity of the broad brushstrokes.

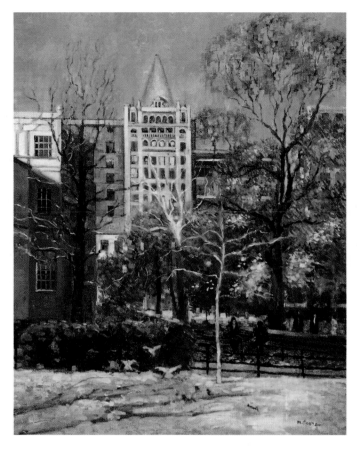

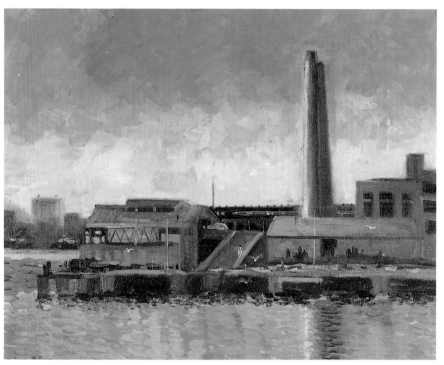

DOWNTOWN IN AUTUMN
(24x20)

In this painting, I wanted to emphasize the contrast between the small, open park and the huge buildings surrounding it. I chose a vertical format which added height to the trees and buildings. The foreground activity—the pigeons and the people strolling in the park—balances the buildings, which create a still, massive center of interest.

This late in autumn the few remaining gold leaves glistened against the cool mass of a blue November sky.

SANITATION GARAGE
(24x30)

This is a wonderful example of finding subjects for paintings in the most unlikely places. When we can view a scene without any preconceived ideas, we greatly expand our repertoire of possible subjects. Even an ugly subject can have aesthetic appeal.

This dilapidated sanitation garage isn't the most beautiful building in New York. However, on a bright, sunny afternoon the ochre smokestacks made a striking silhouette against the brilliant blue sky. I decided to build my composition around this portion of the garage. The reflection of the smokestacks in the water encouraged the viewer to concentrate on them. I was therefore careful to design the water so that it called attention to the smokestacks without drawing the eye away from the central focus of the composition. The linear brushstrokes I used in the water complemented the pattern of the lower portion of the garage. I eliminated some of the more obnoxious details in this scene and added the gulls to lend a poetic touch.

WHAT TO LEAVE OUT, WHAT TO PUT IN

In deciding what to eliminate and what to include in a composition, always keep the main masses in mind. Including too much detail can destroy a good idea.

When approaching a new subject, forget about details. Concentrate instead on what you definitely want to include. Think in terms of major masses—the mass of sky, the mass of trees, the mass of water. Squint your eye so everything is blurred and view the subject in abstract terms. How balanced are the major elements in the composition? Is the focal point dominant? Will a dense clump of bushes create a heavy, uninteresting passage in the composition?

When it comes to adding detail include as little as possible. In outdoor painting too much detail will destroy the main masses. We don't view nature in terms of little branches. Even a non-painter takes in the entire scene.

Some detail is necessary, of course, to help clarify the main elements. However, don't get carried away. Don't depend on details to describe your subject.

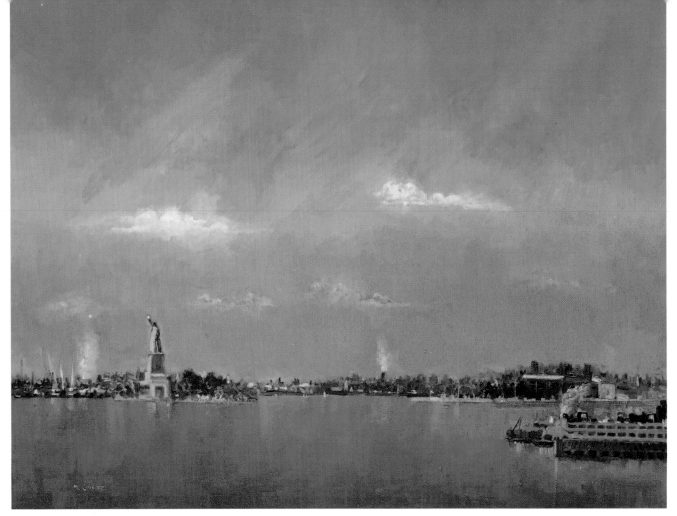

THE NEW LADY

(24x30) Collection of Mr. & Mrs. David Offensend.

I began this painting the day after the scaffolding was removed from the newly restored Statue of Liberty.

The harbor on this summer morning was very cool. The sky and water were a brilliant blue while the new patina on the Statue of Liberty added another cool, bright note.

I subdued the cold sky by exaggerating the warm effect of light shining through the pollution along the horizon line. By working burnt sienna into the dark areas of the water I added more warmth to this big mass. The darker blue in the upper portion of the sky and the lower part of the water helped frame the subject and pull the composition together.

Finally, the orange Staten Island Ferry added another warm note and helped break up the flat, static line that ran across the composition.

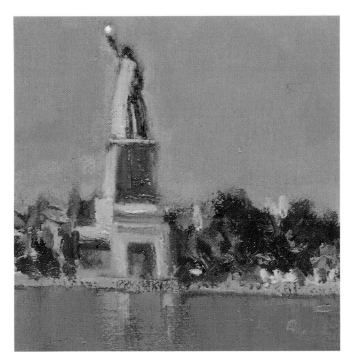

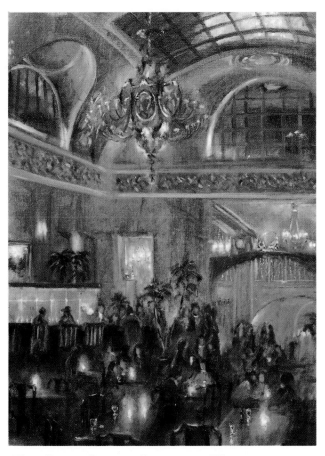

Detail from THE NEW LADY.
I wanted the Statue of Liberty to be a key element in this painting. However, from this vantage point, it was small and distant.

To draw the eye toward the statue I exaggerated the color of the patina and the brilliance of the light side of the pedestal. I also added more sparkle to the torch.

THE PALM COURT, BILTMORE HOTEL

(24x16) Davern Collection, State University of New York, Plattsburg.

I completed this painting just before the famous Biltmore Hotel was demolished. I hoped to capture the casual atmosphere of the Palm Court Bar. This meant eliminating much of the ornate detail in the room.

I decided to leave the walls and elaborate vaulted ceiling in the grisaille, concentrating the action in the lower part of the painting where the crowd had gathered. I wanted to convey the idea that this is a big, lofty space, without letting the setting overwhelm the crowd. Embellishing the glow from the candles on the table helped establish this area as a focal point.

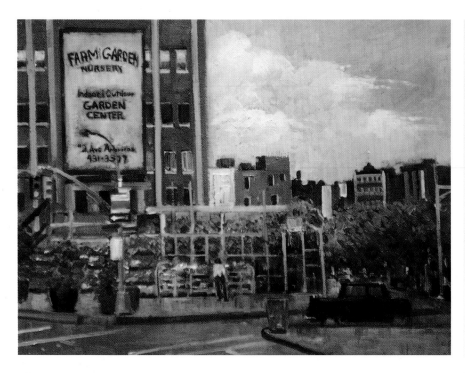

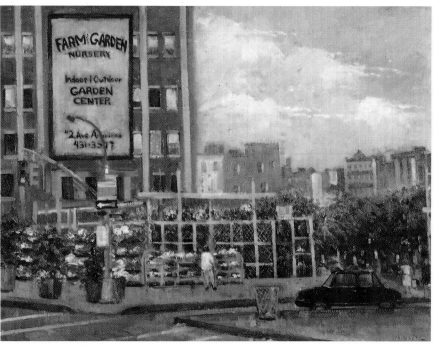

FARM AND GARDEN MARKET—BEFORE
(18x24)

Sometimes a subject has all the right elements, but those elements don't come together the way you feel they should. When I got this painting in the studio, I thought it looked too flat, and the car on the right looked almost like a cutout and was too square. Since the car had stopped for only a minute—not long enough for a detailed sketch—and I don't know much about automobile design, I wasn't sure how to correct it.

FARM AND GARDEN MARKET—AFTER
(18x24)

The flatness was easy to deal with. Scumbling over the buildings in the background with a color in a slightly higher key than the rest of the painting helped them recede. I rubbed a mixture of white, raw umber and dioxazine purple and no medium over the buildings with a round bristle brush (about a number 3), making them lighter colored and setting them in the distance. I varied the windows in the building with the "Farm and Garden" sign and added more bright windows to alleviate the flatness.

I first considered eliminating the car altogether, but I felt something was needed there, and the car added a nice, urban touch. I made a few sketches of compact cars to get a better idea how they are designed, then changed the lines of the car so it looked less boxy. I lightened the color a bit and added a few subtle, light colored details such as chrome and a door handle. These small changes were enough to keep the car in its place, rather than detracting from the overall composition.

Now the painting has more focus, with the distant buildings and the car playing a less significant role.

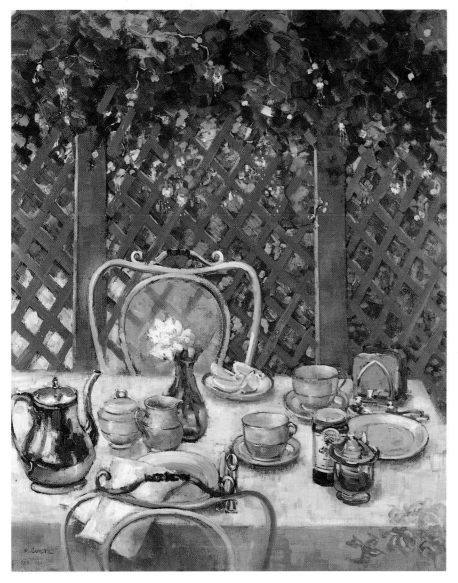

PENTHOUSE GARDEN

(30x24) Collection of
Charles Stamps.

Here, I combined a still life with a scene of garden plants to convey the idea of a living space in a pretty outdoor setting. I liked the idea of trying an interior motif in outdoor light, a light that would lend luster to objects like the silver coffeepot. I also liked the idea of making the painting a study in contrasts—a picnic setting with the table set using good china and silver.

The lattice made a nice backdrop with light coming through its diamond paned pattern. The fuschia was actually just one potted plant that hung over the table, but I painted it as if it covered the ceiling of the garden house, creating a natural frame for the upper part of the composition.

I've often suggested a lot with very little detail. Look at the flower and lemon slices on the table (upper right detail). I used broad strokes and a fair amount of paint. Just adding a white rind says lemon. The stems showing through the vase are almost an abstraction and the vase itself was created with a few strokes.

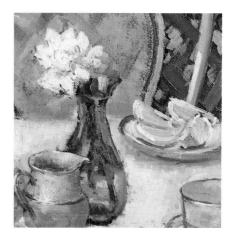

Detail from PENTHOUSE GARDEN. I needed to add some interest to the lower right corner of the painting so I included some of the embroidery on the tablecloth. (The composition would have been too busy had I used the pattern throughout.) A few dabs of slightly thicker paint with a touch of color is all it took.

The Schuylkill River

(30x40) Collection of Mr. & Mrs. Edward Cerullo.

When painting out of town in bad weather I often have only one day to work at the location. Particularly in snowy weather, a cloudy day can be followed by a mild, sunny one—the snow melts and the situation changes entirely.

I therefore selected an uncomplicated subject when I made this winter trip to Philadelphia. Because I faced my subject straight on, there were no difficult perspective problems to deal with. I combined groups of trees, shrubs and buildings into a few large masses for a simple but strong composition.

The beautiful nuances of warm color in the foliage, the silvery, tonal hue of the sky and water and the bright notes created by patches of unmelted snow provided enough compositional interest to satisfy me. The skyline of Philadelphia and the characteristic scull making a wake in the river completed the idea.

By keeping the composition simple I was able to record a lot of information before it got too cold to continue. I use big brushes and a lot of medium so I could block in all the major color notes in the two-and-a-half hours I was there.

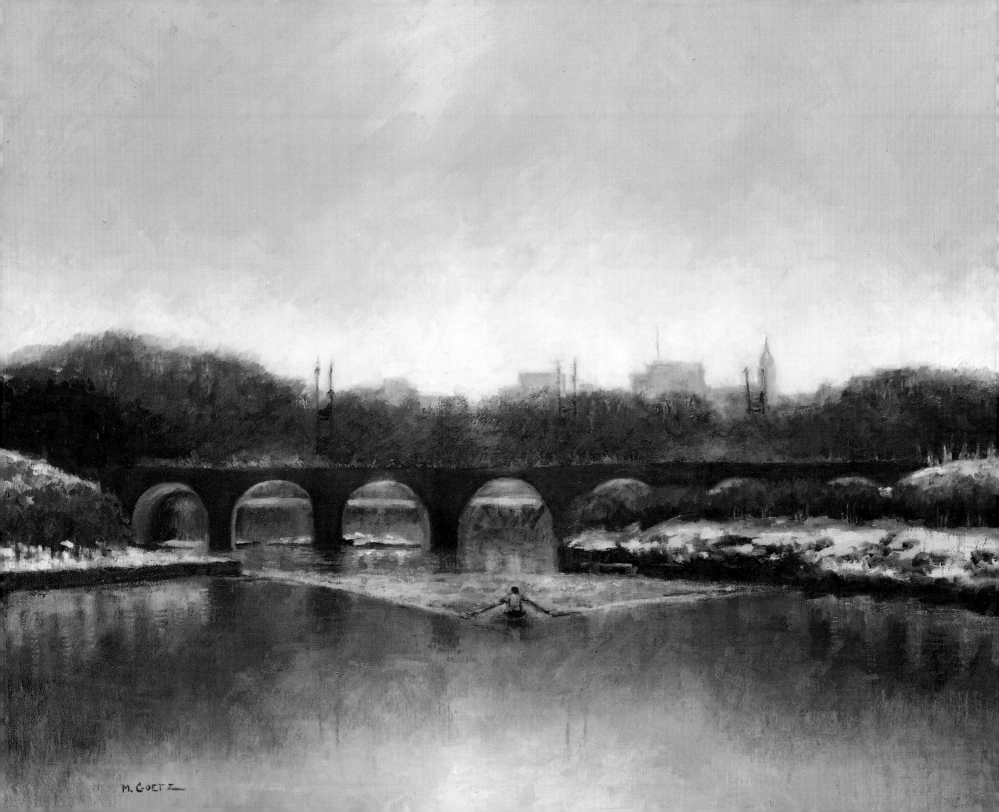

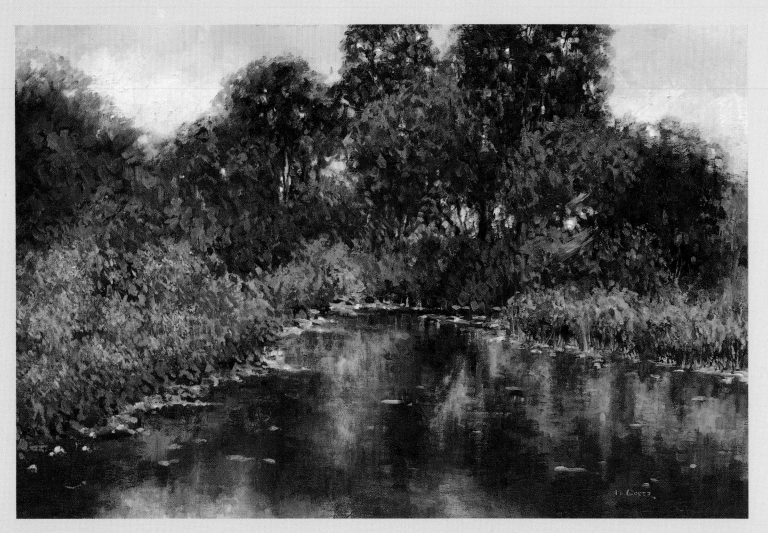

HAMMES'S POND (20x30) Collection of Barbara Tener.

OIL PAINTING TECHNIQUES

I rarely use photographs or sketches when painting landscapes. I find that working at the location imbues my composition with an authentic quality that can't be duplicated any other way. However, working outdoors involves practical considerations that are just as important as aesthetic concerns. I'll begin this chapter with a brief discussion of the equipment you'll need when working outdoors. Then we'll proceed to a step-by-step demonstration of my procedure. Finally, I'll examine sections of several paintings and explain techniques I used to paint flowers, architectural details, foliage and other elements.

Working from nature is exciting. However, don't get so carried away that you waste an outing by forgetting your white paint or wearing unsuitable clothes. (For a discussion of other practical considerations, see the last chapter of this book, pages 132–143.)

Once you begin to paint, use a logical approach—just as you would when painting a still life in your studio. In this chapter I will explain how I begin with a grisaille (value) painting before applying color. Then I'll discuss laying in the big color notes, refining these first statements, building up texture and adding details.

In *Hammes's Pond*, I used a thin wash to describe the water, building up a little more texture in the areas which reflect the light side of the foliage. I wanted to keep the water mass flat and transparent, while concentrating on a crustier paint surface in the trees and flowers. Though I tried to keep the pond as simple as possible, adding a few pebbles and shafts of dry grass along the bank helped clarify the design of the pond. Don't be afraid to exaggerate the occurrence of pebbles along the water's edge or leaves floating on the pond if these details will improve the overall composition. The suggestion of a few light notes can also enliven a subject that includes a lot of dull green trees and shrubbery.

MY PAINTING PROCEDURE

When painting on location, double-check to make sure you've brought everything you need. The following are essentials:

- Paint box and sketch easel or easel box containing: colors, brushes, turpentine, linseed oil, palette, oil cup for medium, container and rags for cleaning brushes, and palette knife for scraping your palette
- Backpack or satchel containing: rags for cleaning brushes, plastic bag for used paint rags, umbrella and extra clothes if needed
- Viewfinder (see pages 30–31)
- Extra canvas or panels

I rarely begin a painting on pure white canvas because it is too difficult to describe the lightest lights on a white ground. I therefore tone the canvas and make a grisaille before I begin to work in color. (See pages 17 and 50–51.)

With warm earth colors, turpentine, and linseed oil I mix a tone that describes the middle value of the subject. I use pure pigment to block in shadows and wipe the tone off with a rag to describe the lightest areas.

STEP 1. TONING THE CANVAS.
In this photograph I have just applied the tone to the canvas for *Calicoon Creek in Summer.* I used a mixture of equal parts burnt umber and burnt sienna. To counteract the cool morning light and green foliage I began with this warm mixture. Had I wanted a cooler ground I would have used less burnt sienna, which is a hot earth color.

STEP 2. WORKING OUT THE MASSES.
I don't begin by making a line drawing or outline of the subject. Instead I work with big masses, as I am doing here. To emphasize the feeling of light emerging through the tunnel of foliage, I began by massing in the dark trees so that this effect would be clearly established from the very beginning.

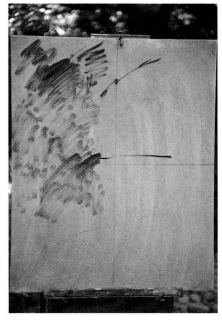

STEP 3. INITIAL LAY-IN.
In this step I didn't want the dark mass of trees and reflection in the creek to cut the painting in half. I placed the dark mass of trees to the left of center and indicated where I wanted the tree line on the right to be.

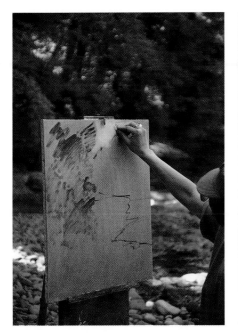

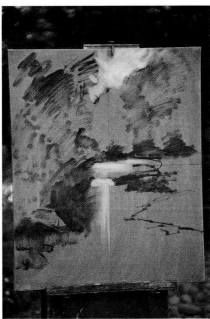

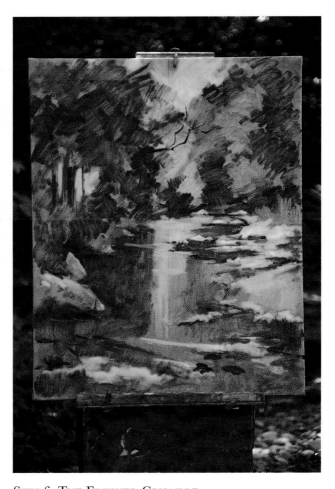

STEP 4. ADDING THE LIGHTS.
At this stage I decide to wipe out the light area of the sky. Since I wanted the focal point to be the reflection of the sky in the water, I had to establish this note, before dealing with the reflection itself. The sky was an extremely important ingredient in creating the beautiful light passage emerging through the dark reflections and shady embankment. To key the sky as one of the lightest notes in the composition, I wiped out most of the grisaille in this area.

I also indicated where I planned to place the pebbled bank.

STEP 5. DEVELOPING THE COMPOSITION.
At this point I have placed the key elements in the composition. I have relied very little on drawing, rather working in abstract patterns to define the focal point. From here I continue in the same way, massing in more detailed shadow areas and wiping out the lightest lights, letting the initial background tone describe the middle values.

STEP 6. THE FINISHED GRISAILLE.
This is the point at which I finished work on the grisaille painting and was ready to begin applying color. You will notice that the technique is still loose and abstract. I didn't want to indicate every pebble and branch. I am more interested in a good description of what the light is doing while clearly establishing the focal point and design of the composition.

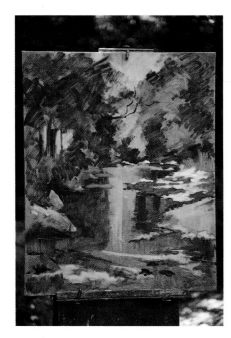

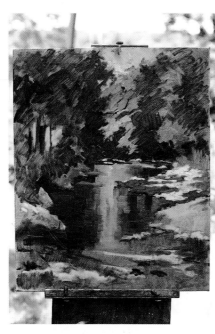

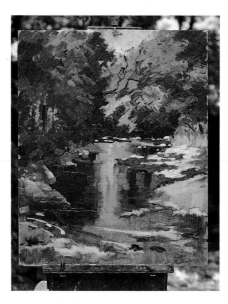

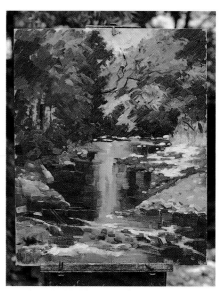

STEP 7. APPLYING COLOR.
When I began to apply color I concentrated again on the focal point. Especially in the beginning, keep in mind what drew you to this subject in the first place.

Here I wanted the reflection in the water to attract the eye first, using the light pebbles to enhance this area as the center of interest.

At this stage, I was still concentrating on big masses.

STEP 8. DESIGNING THE FOCAL POINT.
Dark foliage is what helped create the tunnel look in this composition. I massed this area in early. The light side of the trees was also important because this is part of what is being reflected in the water. I concentrated on this from the beginning, too.

STEP 9. FINISHING THE FOLIAGE.
Working from the focal point out, I made sure my original idea would not be lost in a lot of detail or elements that could be distracting. The reflection, dark shadows from the foliage, and pebbles in light were the key elements. I wanted to clearly define these before moving on.

I intentionally avoided the rapids until the final stage of my initial application of color. The white rapids and complicated pattern they created as they swirled around the rocks could have been distracting. I wanted to keep this passage in its place.

Notice that I move along without trying to finish any one area. I try to keep everything progressing at the same level of completion. It's best not to finish any portion of a painting until you can relate it to everything that surrounds it.

STEP 10. DESIGNING THE RAPIDS.
Finally, I began to design the rapids, using them as a device to draw the viewer into the composition. I kept the foreground very abstract because too much detail would draw the eye away from the focal point. This abstract approach also enhanced the natural character of the rapids and kept them from looking too static.

I continued to work in this direct style, using mostly flat brushes. I wanted to maintain a fresh, clean feeling because the subject itself appeared so uncluttered, with the light clear and bright and the shadows dark and cool.

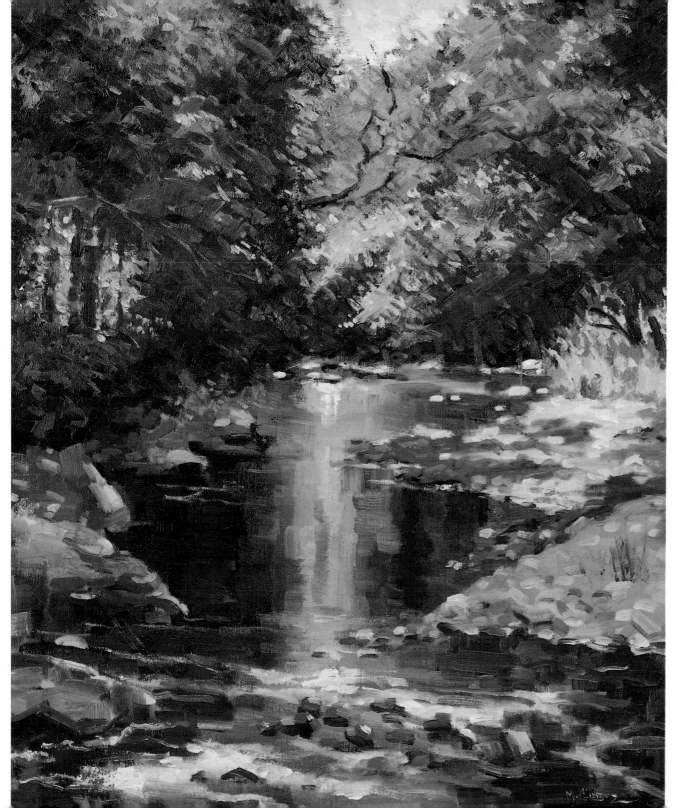

CALICOON CREEK IN SUMMER
(24x20) Collection of Dr. Robert B. Page.

As I finished the painting, I built up more texture in the trees and refined the rocks and pebbles on the bank. However, I was careful not to over-work the painting or destroy the fresh spirit of the scene.

When painting foliage it is almost always necessary to devote some time to building up texture. A thicker build-up of paint will make the trees and bushes look more convincing. I was very careful not to radically alter the color or value as I worked on building up more paint quality. It was a matter of making what was there better, not different.

I also continued to work on the pebbled embankment on the right. The rocks on the left protruding into the water and the rapids looked fin-ished enough and I didn't want to risk sacrificing the spontaneity I had achieved. But the sunlit pebbles needed more attention.

For one thing, I hadn't incorpora-ted enough of the affected orange color on the sunlit portions of the bank. The pebbles also needed more modeling, to create a smoother tran-sition from shadow to light and to indicate more contour in the mound of pebbles in half light (closer to the foreground).

I added just a little pure white pig-ment to the reflection. I did nothing else to the water.

To mix the tone for my grisaille painting, I use one or more of the following earth colors—raw sienna, burnt sienna, raw umber and burnt umber. The burnt pigments are warmer than the raw colors and burnt sienna is the warmest of all. Staining my canvas with a warm tone helps me force the light effect from the very beginning.

Which earth colors I use depends entirely on the subject and the light conditions. However, there are no hard and fast rules about this. It is largely a matter of experimenting and coming up with a mixture that you feel comfortable with. In most instances I use burnt umber with just a little burnt sienna. Under certain circumstances, I will change my formula, using a color that contradicts how cool or warm the subject itself is.

To mix the tone I begin by squeezing a small pile of paint on my palette. How much pigment I squeeze out depends upon how big my canvas is and how dark I want the tone to be. For example, I squeeze out a pile of paint about the size of a nickel for a 20x24-inch canvas and a tone in the middle value range. You can gradually add more paint or turpentine to get the right consistency. It is better to begin with modest amounts. Otherwise you can end up with more mixture than you need and a sloppy mess as well.

Using my palette knife I work into the paint a mixture of ten parts turpentine to one part linseed oil (the same proportions I use in my medium). You want this mixture to be juicy and plentiful enough to spread evenly over the canvas with a rag. Be sure to keep working the paint into the turpentine mixture until there are no more lumps. Also be sure to use an absorbent rag (cotton's best) or paper towel. You won't be able to spread the tone on as efficiently with a rag made of synthetic fabric.

I wish I could be more precise about how much paint to squeeze out, how much medium to mix in, and what combinations of paint to use under particular circumstances. But this is something you acquire a feel for.

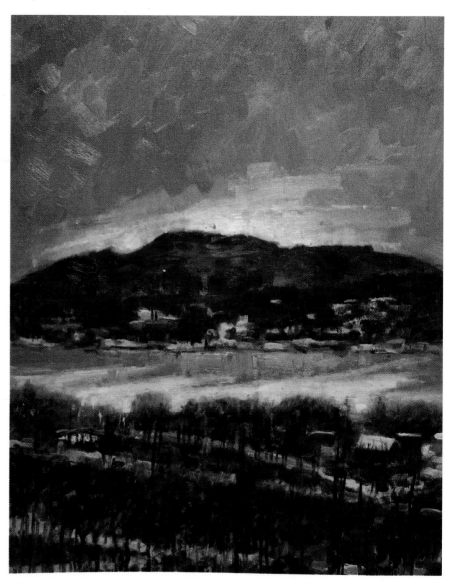

NEWBURGH IN WINTER

(20x16) Courtesy of Newman Galleries, Philadelphia.

Had I not begun with a warm grisaille, the contrast between the warm trees and the cool silvery light on the water and structures in the distance might have been too great. The burnt sienna tone pulled the composition together, resulting in a warm, harmonious palette.

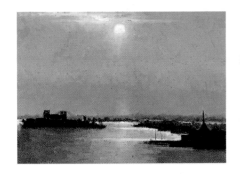

ELLIS ISLAND AT SUNSET (16x20)

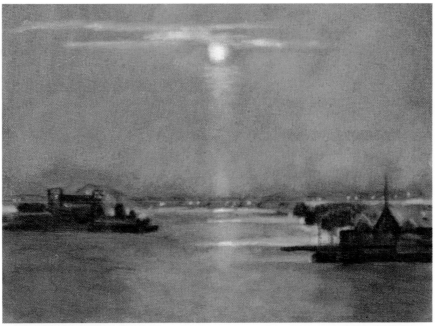

Grisaille for ELLIS ISLAND AT SUNSET. You can begin by using either a wet or a dry grisaille. I prefer the wet method, blocking in shadows with paint and wiping out lights with a rag while the underpainting is still wet. A dry grisaille is done like a painting, except that you use only two colors. Let the underpainting dry, then lay in the composition using earth colors and white paint.

Use more paint if you want a dark tone. If you plan to work in a high key, use more turpentine and linseed oil and apply a thin tone. Remember to make the value of the tone in the same range as the middle value of the subject.

Grisaille for THE SCHUYLKILL RIVER. In making this grisaille I was careful not to wipe out too much of the tone in the sky and water masses. Though the sky was bright gray, it was not as light as the patches of snow. To block in the snowy passages I rubbed out all of the grisaille so the bare canvas was exposed.

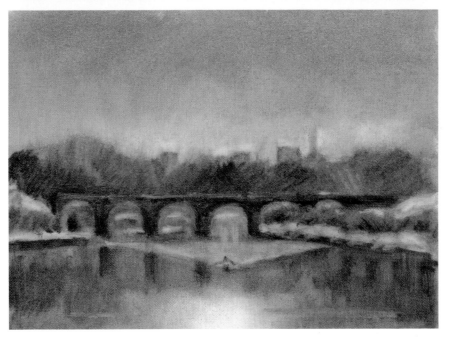

THE SCHUYLKILL RIVER (30x40)

BRUSHWORK

When painting landscapes I like to avoid brushwork that is too finished and controlled. By applying the paint freely I can concentrate on an overall impression of my subject, without getting bogged down in details or refinements that destroy the fresh quality I want to convey.

The type of brushstroke I use depends on the subject. For example, a broad stroke using a flat brush is ideal for painting winter scenes.

If I want to build up a lot of texture I load my brush with paint and use a round brush. This technique is good for leafy trees, flowers and shrubbery. To build up thick layers of paint, I work over a surface that is almost dry and make several applications, using plenty of paint.

Either a round or flat brush can be used for drybrushing. I often use this technique when painting cascading water, softening edges or subduing an area that is jumping forward. To drybrush, use no medium and drag the pigment over a dry, rough surface. Squeeze the colors you want to use for drybrushing onto newspaper, which will absorb the oil in the paint.

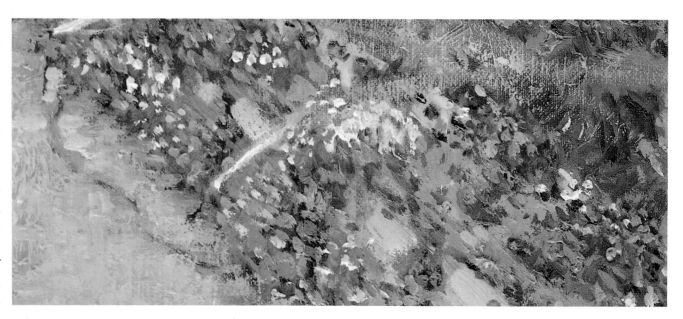

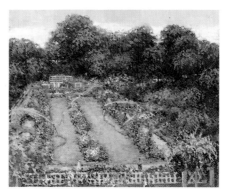

WATERING THE ROSE GARDEN (20x24)

Detail from WATERING THE ROSE GARDEN.
An impressionistic technique was the best approach in this instance. I applied dabs of color to indicate the roses and worked in a loose style. Since the garden itself is so symmetrical, a freer, less controlled technique was more effective than a finished one. Allowing some of the underpainting (raw umber mixed with a little burnt sienna) to show through warmed the foliage.

To paint the spray from the sprinklers I drybrushed over the textured surface I had built up in the flowers and trees.

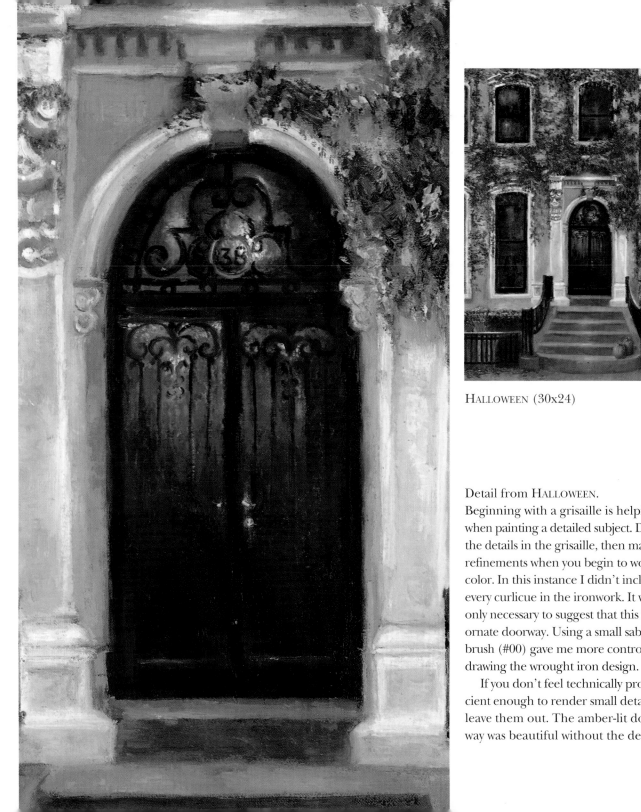

HALLOWEEN (30x24)

Detail from HALLOWEEN.
Beginning with a grisaille is helpful when painting a detailed subject. Design the details in the grisaille, then make refinements when you begin to work in color. In this instance I didn't include every curlicue in the ironwork. It was only necessary to suggest that this is an ornate doorway. Using a small sable brush (#00) gave me more control in drawing the wrought iron design.

If you don't feel technically proficient enough to render small details, leave them out. The amber-lit doorway was beautiful without the detail.

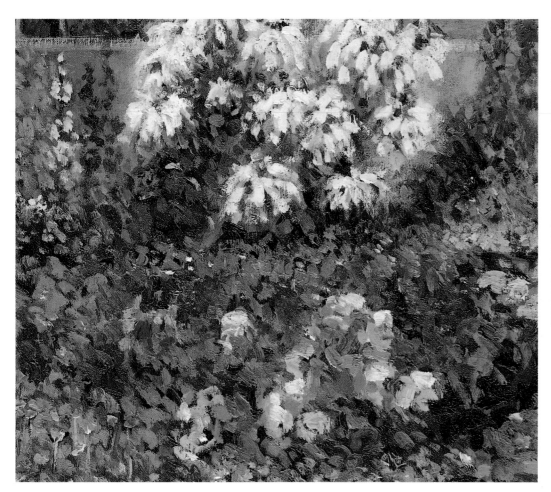

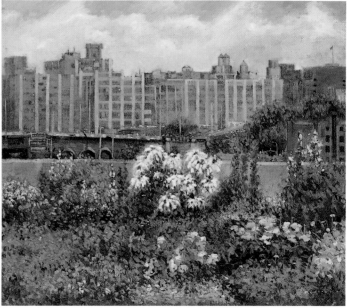

ROOF GARDEN (28x32)

Detail from ROOF GARDEN.

Notice that I have not concentrated on petals here. I was more interested in portraying an overall impression of the flowers—just a dab of color or a carefully placed stroke can suggest a great deal. However, I spent many hours working on the flowery foreground in this painting, building up layers of paint, without changing the original color statements. (I did, however, change the big mum from yellow to white. You can see that I did this by applying thick strokes of white paint over the original yellow color.)

MORTON STREET PIER (11x14)

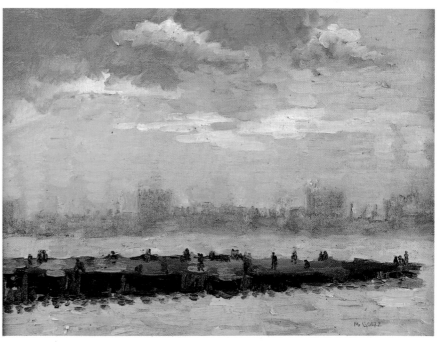

Detail from MORTON STREET PIER.

Whereas round brushes are great for painting foliage and flowers (as in *Roof Garden*, facing page), flats work well when painting architecture and water. In this detail you can see that a few confident strokes suggested light on the pier, color changes in the water and the blocky character of the buildings in the background. In this detail it is difficult to distinguish the people on the pier. However, in the complete painting the more refined figures help clarify those I have merely suggested.

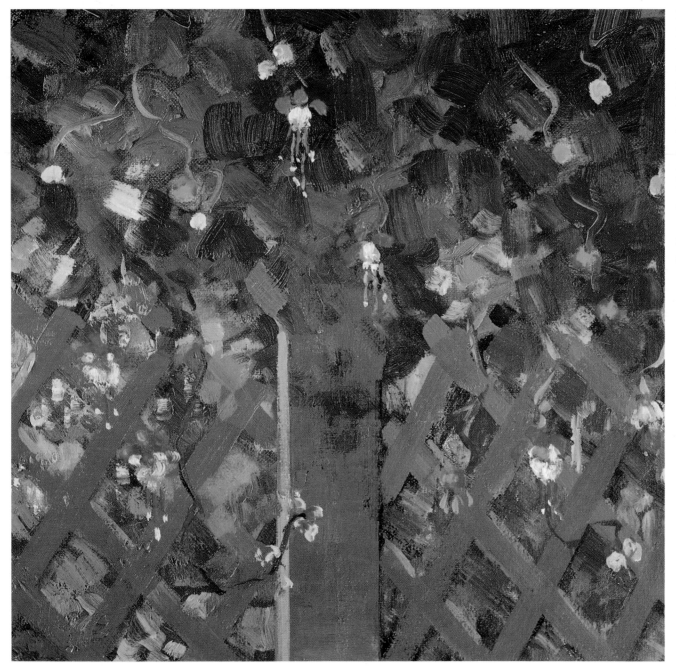

Detail from PENTHOUSE GARDEN. In this painting I departed from my usual approach to painting greenery and flowers. I used flat rather than round brushes and I didn't build up a lot of thick paint in the leaves. I wanted the fuschia to carry out the garden house motif, without distracting the viewer. The still life was the focal point—not the flowers overhead. A thick build-up of paint would have called too much attention to this area.

I also refined the blossoms a little more than I usually do, using a small sable brush to add delicate details.

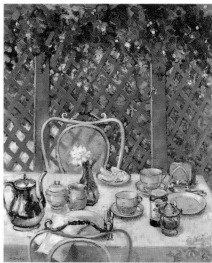

PENTHOUSE GARDEN (30x24)

CORRECTING YOUR WORK

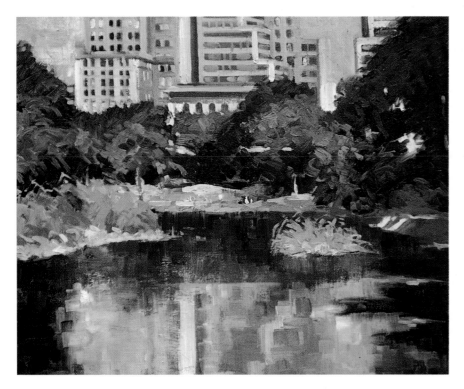

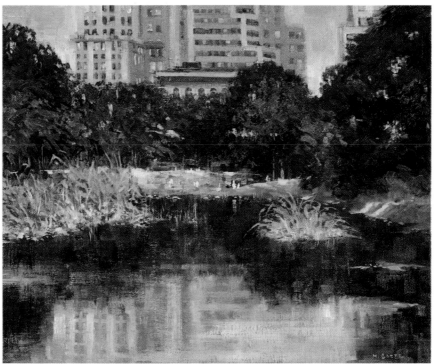

POND IN CENTRAL PARK—BEFORE
(20x24)

This is a good example of the stage at which I usually decide to move away from the location and finish the painting in my studio. The basic information has been recorded, but the painting just isn't finished yet. The foliage is too thin. The water looks too solid. I wanted a bluer sky. I was also having difficulty with the reflections in the water. I began work on a mildly gusty day—not windy enough to create constant ripples in the water, but blowing enough to blur the reflection. On subsequent visits to the location, the weather was very calm, resulting in a crystal clear reflection. Since I definitely wanted the buildings to be of secondary importance, clear reflections of them in the water would have defeated my purpose. (I might have felt differently had the buildings been more attractive.)

POND IN CENTRAL PARK—AFTER
(20x24)

The solution was to finish the water in the studio. Here I also noticed some small errors. A long section of one of the buildings jumped in the reflection. To correct this I simply softened the edges and subdued the color. Also, on the left, I had indicated the sky reflected in the water where the side of a building should have been. These were small errors, but still distracting.

After making these corrections, the rest was a matter of refining what I had already painted. I built up more texture in the trees and opened them up by adding more light between the leaves. I also worked on the design and alignment of the windows and broke up the tree reflections in the water so they looked less solid. Finally, I added a gentle ripple, which eliminated a boring reflection of buildings in the water.

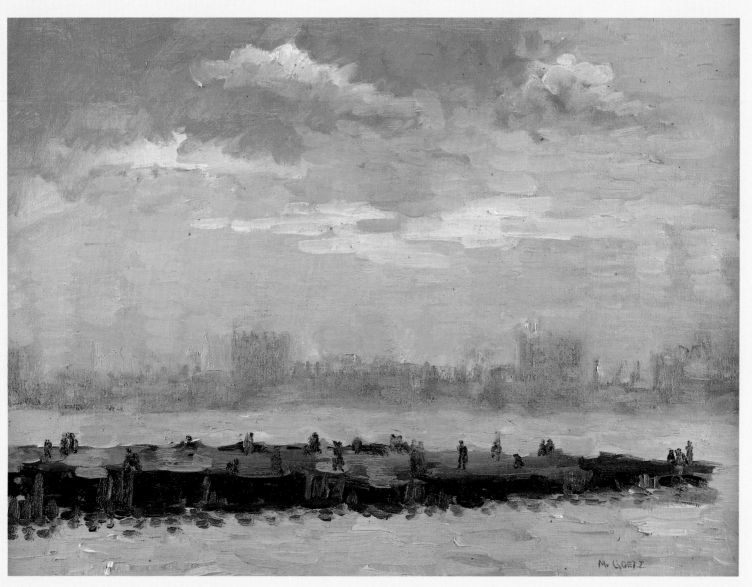

MORTON STREET PIER (11x14) Collection of Mr. & Mrs. James Roy.

Skies, Water, Trees and Flowers

Skies, water, trees and flowers are key elements in painting landscapes. A fabulous sky can often turn an otherwise dull scene into a perfect subject for a landscape. In another instance a sylvan pond or a stream running through a thick forest may be just the element that lends enough intrigue to a subject to make a good composition. Trees, grass and shrubbery, of course, are often the featured attractions in a landscape. Even in winter when the trees are bare, interesting forms created by the barren branches can be the very aspect of a scene that makes it a paintable subject.

Of these elements the sky is the most important for it supplies the light source. A bright blue sky will cast a cool light on your subject. Dark clouds moving across the sky will create shadows and brilliant light passages as they move in front of the sun. A pale yellow sky will bathe the landscape in warm light. The sky has the greatest impact on the color of water.

In *Morton Street Pier* (facing page), you can see that the color of the water reflects the color of the sky. That doesn't mean they will be the *same* color—or value, for that matter. But if the sky is bright blue, the water will reflect some variation of that color. In this painting the sky and water range from warm earth colors to bright blue. I described these changes, but avoided making abrupt transitions.

My style of rendering the elements in a landscape painting changes constantly. Sometimes I describe the water using horizontal strokes with a round brush, while at other times—as in *Morton Street Pier*—I use a wide, flat brush and paint the water *a la prima*. I sometimes paint clouds as abstract forms and at other times remain more true to nature. It all depends upon what seems to suit a particular idea.

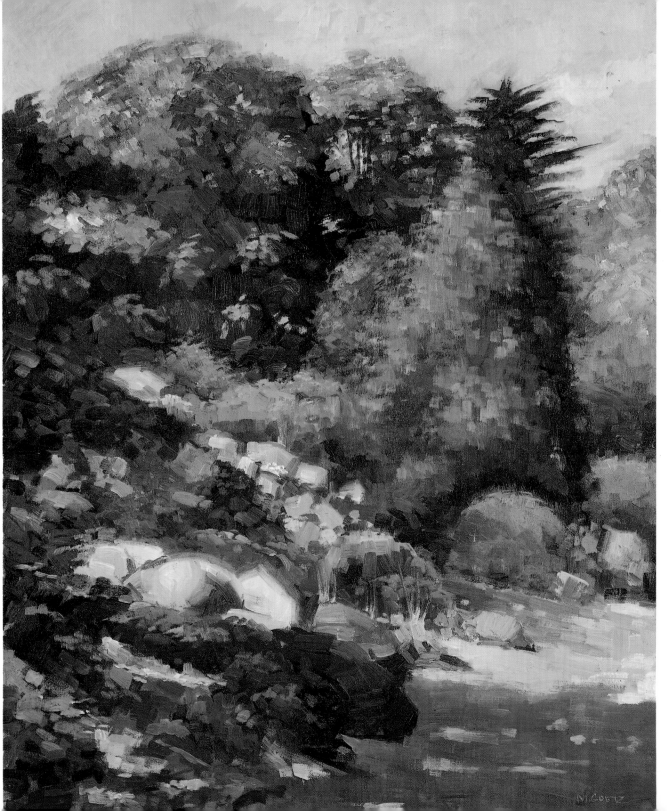

THE ROCK GARDEN

(30x24) Courtesy of James Cox Gallery, Woodstock, New York. Especially on a bright sunny day, rocks make interesting landscape subjects. Under sunny light, their irregular forms usually create fascinating light and shadow patterns. The light side will often pick up a soft highlight, while shadows cast from the rocks can create beautiful patterns in the foreground.

In this painting of the Rock Garden at the Brooklyn Botanic Gardens I worked under sunny morning light. With the sun lower in the sky, stark light and dark masses were created by the array of boulders and smaller rocks. The profusion of ochre rocks also contrasted effectively with the bright blue sky.

Rocks also provide a good opportunity to improvise. Don't be afraid to alter the form if it will improve your composition. Just be sure to keep the light and shadow masses accurate.

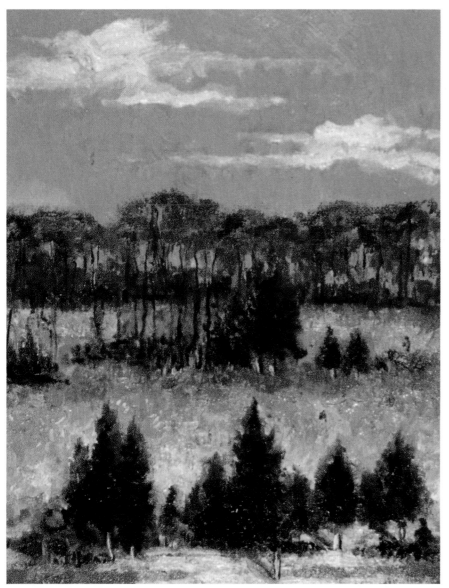

PASSING STORM

(20x16) Courtesy of Grand Central Art Galleries, New York.

The big expanse of gray in contrast to the gleaming sky visible above the trees created just the kind of dramatic effect one hopes for. As is often the case, the sky remained this way for only about ten minutes. More gray clouds rolled in and the portion of luminous sky disappeared.

When painting a changing sky, concentrate on capturing the effect that attracts you most and work on the rest of the painting when the sky changes again.

MEDITATION HILL

(12x9)

In this painting I have included quite a bit of information on a small format. A vertical composition helped alleviate the clutter, drawing the eye away from the array of trees in the foreground and toward the bright blue sky. I varied the shape of the pine trees and emphasized their form by designing a halo effect in the grass behind them. A patch of sunlight in the foreground repeated this warm statement.

SKIES

Even a cloudless sky can lend drama to a landscape painting. A patch of bright blue sky can add a striking note, while an expanse of flat gray sky has a subtle impact of its own. The addition of clouds and sun, however, can create some of nature's most stunning effects.

Study the clouds carefully before you begin to paint. Is the sky full of big billowing clouds or streaks of elongated ones?

When painting a cloudy sky, it is important to work quickly. Even on a calm day, clouds still change form and move across the sky constantly. On a gusty afternoon as the clouds change, the light changes. When applying the grisaille, loosely indicate where you want to position the clouds. In the beginning, just shoot for an impression of the type of sky you have that day.

Don't begin by wiping out big white holes in the sky area to indicate clouds. Clouds aren't pure white. They radiate many different nuances of color. However, overworking clouds can destroy their innately light, airy character. Indi-cate that value and color changes occur, but don't go overboard.

Sunrises and sunsets are also extremely difficult to paint. The color and quality of the light changes almost every second, and the vivid orange and red colors are difficult to paint without garish results.

You can begin work on a sunset painting before the sun begins to set. Don't apply color; just arrange your composition in the grisaille, then wait for the right moment.

The sunset lasts only about ten minutes, so it's important to work quickly and concentrate on an overall impression of what is occurring. Keep in mind that it will grow darker by the moment and key the painting a little darker than seems accurate in the fading light. Otherwise when you view the painting indoors, under brighter conditions, it will look too light.

Stormy weather can also produce striking light effects in the sky. The pearly quality of a gray sky is beautiful, and the streaks of silver light that break through the clouds are breathtaking.

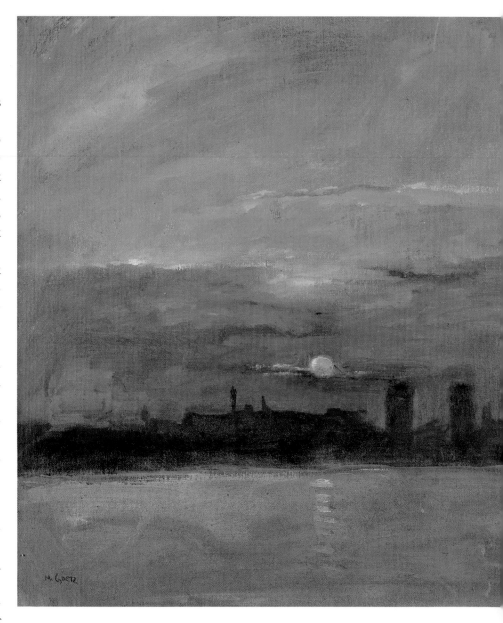

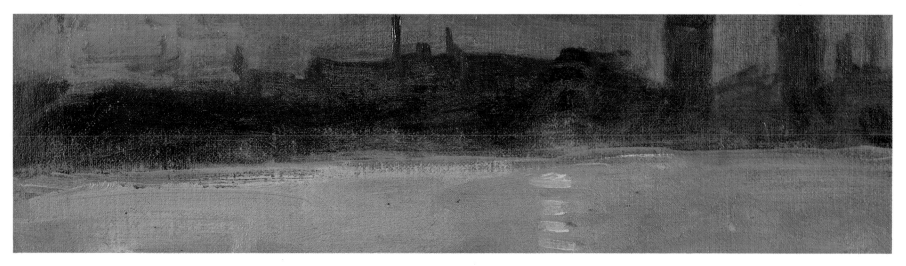

SUNSET

(20x16) Private collection.

There is a point, as the sun is setting, when the glare is so intense it's almost impossible to work. The sun is shining right in your face and even a sun visor doesn't help reduce the glare much. It's best to wait until this moment has passed, and the sun is lower, to begin work on the sky itself. This is when the rich orange, yellow and red colors occur, as you see in this painting. I've also exaggerated the green color of the water to attract the viewer. Leaving some of the burnt sienna grisaille showing through kept this passage in harmony with the rest of the colors in the painting.

Detail from SUNSET.

In this detail you can see that I have suggested the buildings with a thin wash, indicating very little detail. To draw attention to the setting sun I built up more paint in this area, using pure pigment and no medium.

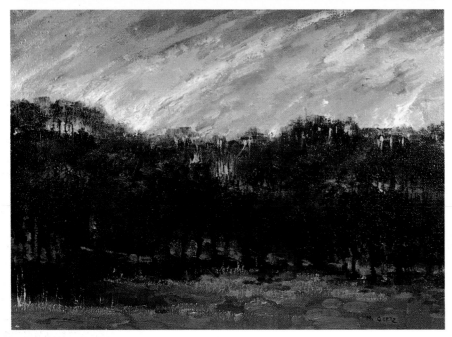

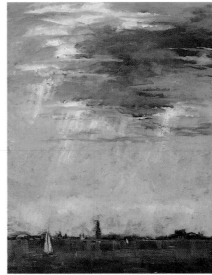

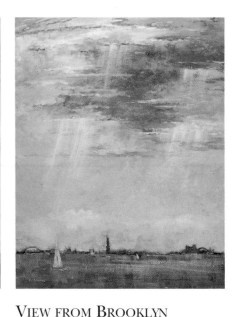

BUCKS COUNTY SUNSET
(10x14) Courtesy of Newman Galleries, Philadelphia.
In this painting, the dramatic sky, streaked with gold bands, was the most important element. I painted the sky *a la prima*, working in angular strokes. I didn't worry about refinement, focusing my attention on color variations instead. To break up the mass of dark trees, I exaggerated the light pouring through openings in the foliage.

VIEW FROM BROOKLYN ANCHORAGE—BEFORE
(30x24)
Gusty winds combined with a sky full of clouds make painting in windy weather especially difficult. Mounds of clouds constantly move across the sky, blocking out the sun one minute, flooding the sky with light again as they move on. This was the situation when I worked on this painting.

This is what the painting looked like when I finished work at the location. The clouds were moving so fast I knew it was fruitless to try refining them. Working in these conditions, I concentrate on describing as much of the overall situation as possible.

VIEW FROM BROOKLYN ANCHORAGE—AFTER
(30x24) Collection of Dr. & Mrs. Bruce Sorrin.
In the studio, I modeled the clouds and highlighted the brilliant colors that occurred around their edges. I emphasized the shafts of light more, making them lighter, brighter, and more clearly defined. I then drybrushed the shafts with a flat brush so they wouldn't overwhelm the rest of the composition. I was careful to keep the shafts of light parallel.

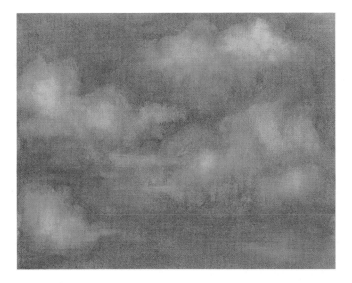

STEP 1

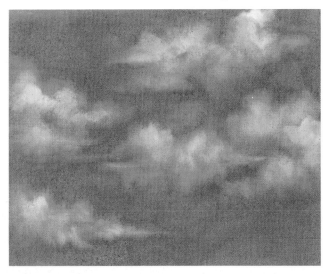

STEP 2

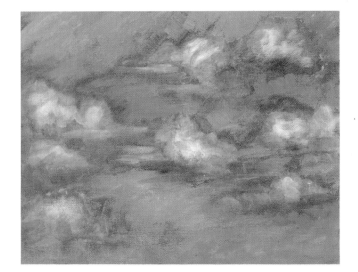

STEP 3

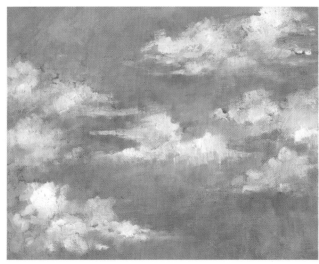

STEP 4

PAINTING CLOUDS

STEP 1. I begin by placing the clouds in the composition. I don't indicate the lightest, most luminous portions of the clouds until I have decided how to work these passages into the composition. I describe only the middle values in the beginning, as the very lightest and darkest portions of the clouds will tend to jump unless tastefully arranged.

STEP 2. When I have decided on the placement of the clouds, I refine them, wiping out the lightest lights and laying in the darkest areas. I don't attempt to make an exact rendering of the cloud I'm studying. I avoid too much detail, as I don't want the clouds to look like objects.

STEP 3. When it is time to apply color, I begin by laying in the sky color. This helps define the shape of the clouds. It also enables me to relate the clouds to the color of the sky, rather than the color of the grisaille, which is much too warm.

STEP 4. When I begin work on the clouds, I avoid piling on too much paint. Otherwise the clouds will appear too solid. I also study the affected color of the clouds, realizing that pure white pigment won't produce convincing results. When refining the clouds I pay attention to their edges. Hard-edged clouds can create a cut-out look. Finally, don't be afraid to use your imagination to make the design of the clouds more interesting.

WATER

Water is innately beautiful. It is shimmering and luminous, and the color constantly varies. The same lake can look green one day and blue the next. It all depends upon the prevailing light conditions and the color of the sky.

Many subtle color changes can be detected in a mass of water. Further variations occur when a breeze causes ripples in the water, a boat creates a wake, or when a shaft of light hits the water and causes it to sparkle.

The most important thing to remember when painting water is to keep it simple and transparent. Striking effects can be created by working color and other variations into a composition that includes a body of water. However, it's important to keep these variations subtle, and not to clutter up the composition with lots of ripples or to pile on thick layers of paint.

Reflections are often an important consideration. I rarely render reflections as a crisp mirror image. If they're too defined, they draw attention away from the focal point. I therefore usually mute or soften the reflection.

MOHONK LAKE

(18x24) Collection of Dauphins Depositors Bank and Trust.
This idea became much more interesting when a gust of wind created silvery ripples in the lake and eliminated much of the crisp reflection from the trees and cliffs. The reflected colors are still there, however, slightly muted to avoid conflict with the center of interest—the column of light in the water reflecting the sun. The ripples and light passage also alleviated the dense green look of the water and foliage.

LAMBERTVILLE BRIDGE

(16x20) Courtesy of Newman Gallery, Philadelphia.
Here, I featured the reflections more than I usually do, but still didn't make them a mirror image of the bridge and foliage in the background. I tried to portray the water more as a reflection of the silver gray sky instead.

Since water is translucent, you shouldn't build up a lot of paint or texture. But if you decide to feature the water, as I did here, you may have to build up a bit more paint in that area to avoid a dull passage. Painting the sky in a thinner technique draws the eye toward the water and lends more focus to the bridge, which was the main element in the painting.

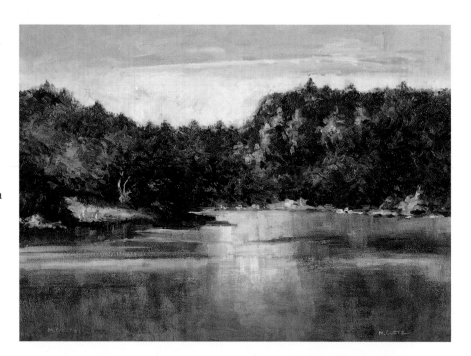

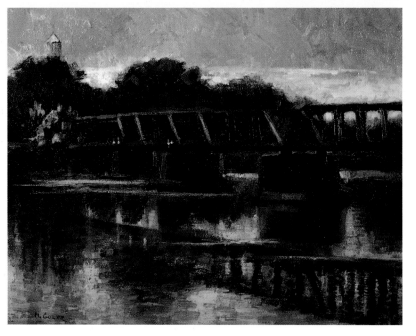

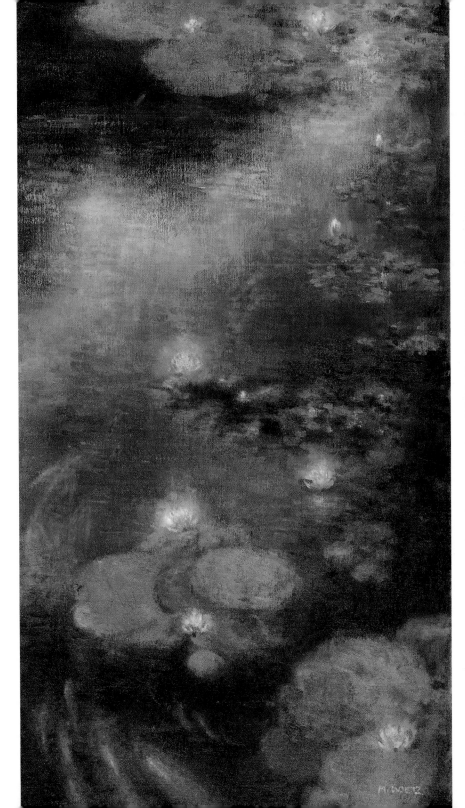

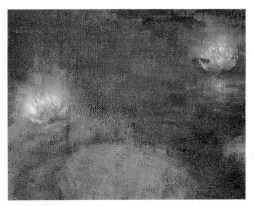

Detail from A Secret Place.
The shimmering, bright lilies looked almost like candles floating in the warm-colored water. I embellished this effect when finishing the painting in the studio. I painted the lilies using white pigment in the lightest areas, and then drybrushed the edges to soften them and create a glowing effect.

Detail from A Secret Place.
I laid in the fish, and then drybrushed over them with the color of the water. This enhanced the illusion that they're underwater. I also softened their edges, so the fish wouldn't look like cut-outs.

A Secret Place

(40x20) Collection of Richard Fuchs. The lily pond at the Brooklyn Botanic Gardens is one of the most beautiful spots in the park. I positioned myself on the edge of the pond, looking directly into the water. The vertical format and the goldfish trailing through the water added a certain oriental touch that made the composition more striking. The goldfish also helped lead the viewer into the less intricate upper portion of the composition.

HOBOKEN FERRY SLIP

(10x20) Collection of the Union League Club, New York.

Though the building itself is interesting, the subject wouldn't have been as paintable on a clear day without the snow. On this winter day, however, the pearl gray sky and water and the contrasting snow-covered patterns made this a much more interesting subject. Using a long, horizontal format also helped, because all the elements in the composition were pretty simple. Finally, adding a few boats in the water and some lights along the shoreline helped enliven the composition, without destroying the simple concept that made it appealing in the first place.

Remember that snow is not pure white. Rendering it with white paint straight from the tube won't capture its color accurately. Like anything else, the color of snow depends on the light conditions and on its relationship to other elements in the composition. Here, for example, the snow is picking up the sky colors.

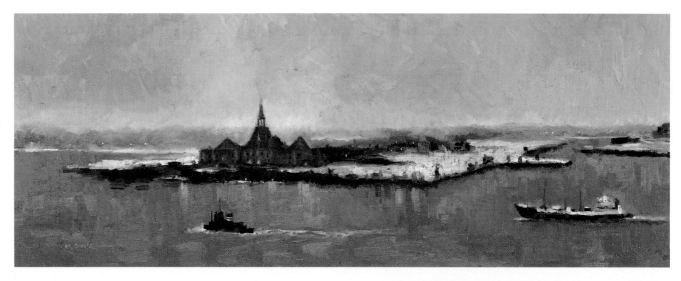

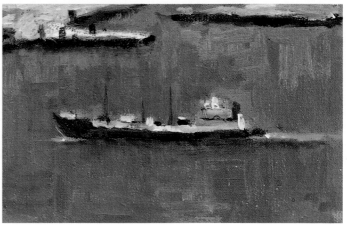

Detail from HOBOKEN FERRY SLIP.
Remember that gray is a color, too. When you paint a gray sky, notice the many subtle changes occurring in the color. Portions can look orange-gray (try adding cadmium orange) or pink-gray (rose madder or permanent rose). For this sky, I created the yellow-gray portions by working yellow ochre into the wet paint.

Mixing black and white will not result in a beautiful pearl gray sky. In fact, I don't have black on my palette and most of the Impressionists avoided using it.

Detail from HOBOKEN FERRY SLIP.
When painting the boat and its wake, I laid in the water first and then added the boat. I sketched in the boat in the grisaille, then refined it with the tip of my brush. I suggested the wake, using a little pure white paint.

VIEW FROM BATTERY PARK

(28½ x 39½) Collection of Mr. & Mrs. David Winterman.

I used a thin wash to cover the canvas and record everything I needed to know in one outing. In the studio I added more depth to the horizon by modeling the shoreline and refining details. Enhancing light notes in the composition (for example, the wake from the boat in the foreground) and creating a more luminous quality to the water made that area less flat and dull. I designed the cloud streaks with a thin wash, and built up texture later with pure pigment.

This is a large painting, and many hours were spent finishing it indoors. However, the basic painting was there after that first day working at the location.

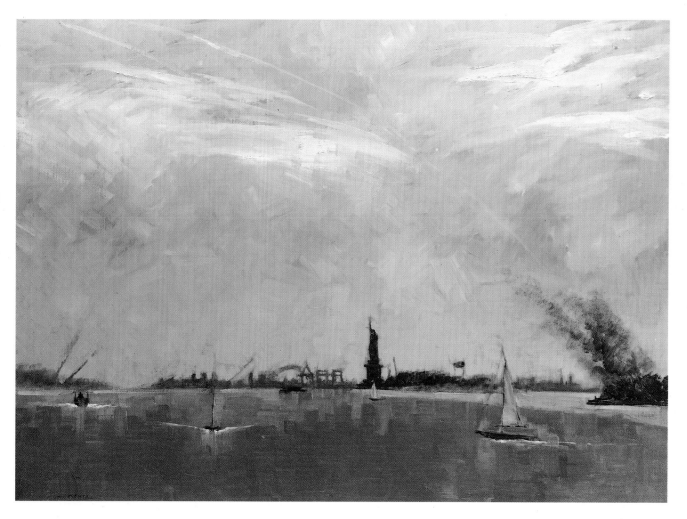

TREES AND FLOWERS

Painting foliage provides a great opportunity to dip into piles of paint and build up rich textures. Whereas water, clouds and sky can be unconvincing if not kept thin and more transparent, the opposite is true with leaves. I usually spend many hours in my studio finishing the foliage in a painting. However, I'm careful to lay in the painting as accurately as possible before building up the paint quality. The actual color of the trees and general light effect in the painting change very little while I'm building up texture in the trees and bushes.

Accurately record the placement of the light and shadow masses. Though shadows will change as you work, take care to keep the cast shadows from the trees all at the same angle. You don't want one tree to look as if it was painted at 2:00 P.M. and another as if it was painted at 4:00 P.M.

Trees have a light and shadow side just like other objects. It's important to design the light and shadow masses so that trees don't look spotty, and the shadow mass and light mass appear to be part of the same tree.

Branches and tree trunks are tricky to paint and in most instances, I recommend including as few as possible. (This doesn't apply to bare trees in winter.) When looking at a clump of distant trees the eye doesn't record every little twig. What we want to perceive instead is an impression of trees. Showing portions of the sky visible through a mass of trees automatically creates the illusion of branches simply because we know they must be there.

When painting flowers it's difficult to make an exact rendering of them as they occur in nature. Begin by getting a general idea of how the flowers are arranged, blocking them in in a fresh, loose style. As long as you get a general feel for their character and placement in the composition, the results can be convincing. Incorporating too much detail can also destroy the natural, delicate character of flowers. If you'll be working several days on a flower painting, some blossoms will wilt. Refine those from memory.

POND IN HUNTERDON COUNTY
(30x24) Courtesy of Newman Galleries, Philadelphia.
This painting is a good example of how to paint branches and tree trunks. When painting bare portions of a tree I usually eliminate most of the small branches and many of the bigger limbs. It only takes a few to create the illusion and I am more interested in depicting the beautiful light shining through the branches than concentrating on painting a lot of little twigs.

Even though this was painted on a gray day, and there were no distinct light and shadow patterns in the tree trunks, I indicated that there was variation in the color and shape of the trunks and avoided making them too dark and flat.

Detail from POND IN HUNTERDON COUNTY.

It's generally necessary to alter the design of the branches. They often make an odd formation, twisting in a distracting way or pointing straight up. Since this painting has a vertical format, including branches that protruded horizontally helped the composition. Artfully designing the branches can also lend some personality to the trees and add life to the overall composition.

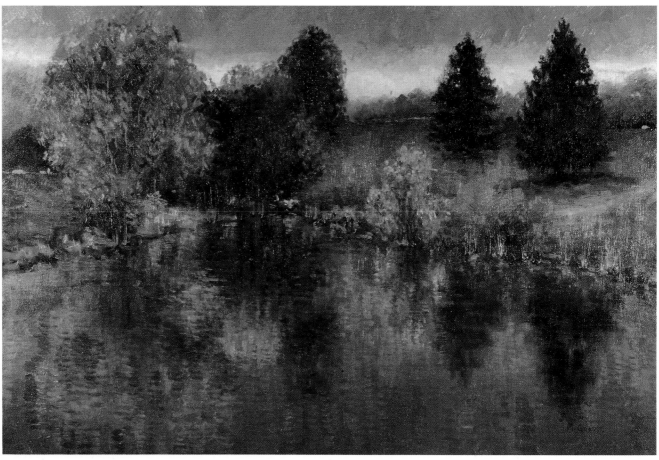

AUTUMN REFLECTIONS

(24x36) Collection of Rittenhouse Hotel, Philadelphia.

The evergreens supplied some color relief from the blazing color of the October trees. The pond also added a center of interest beyond the brilliant fall colors, which I intentionally subdued. The little yellow bush in the center ties the two halves of the painting together by bridging the warm colors on the left and the cool colors on the right.

Evergreens tend to be the same basic shape. Make sure to vary the size and color of each and don't make the edges uniform or they'll look boring. Building up a lot of paint in evergreens also helps because an impastoed (crusty) surface makes the dull green color more interesting.

CHERRY LANE IN SPRING

(10x30) Collection of Barbara Tener. I have painted this view of the Cherry Lane at the Brooklyn Botanic Gardens many times. However, devising a composition that doesn't look too symmetrical is a challenge, as the trees are lined up parallel to each other, with a wide expanse of lawn in between.

In this case I positioned myself well to the right of the center. This created an asymmetrical balance in the composition. The arrangement also helps move the eye through the painting.

I used a very long format. In this way I was able to compose the painting with only the tops of the trees and very little of the vibrant green lawn included. A bit of the sky hinted at the panoramic feeling of this subject and kept the composition from looking too closed in.

CHERRY LANE

(10x20) Courtesy of Newman Galleries, Philadelphia.
In this summer painting I again used a horizontal format, but not as elongated as in the spring version. Though I felt I could include more of the lawn in this painting, I still positioned myself to the right of center to make an asymmetrical composition. Shadows stretching onto the lawn helped break up this mass.

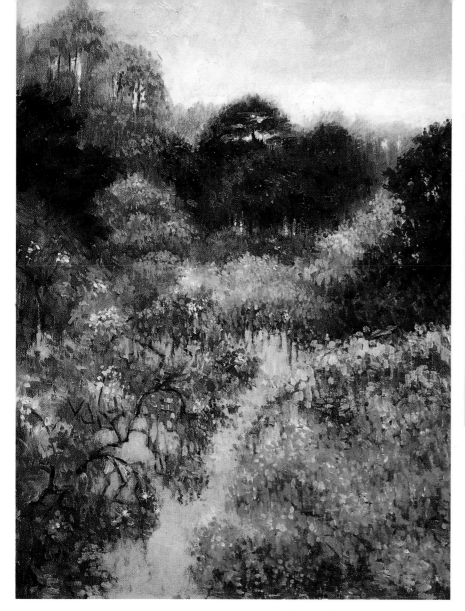

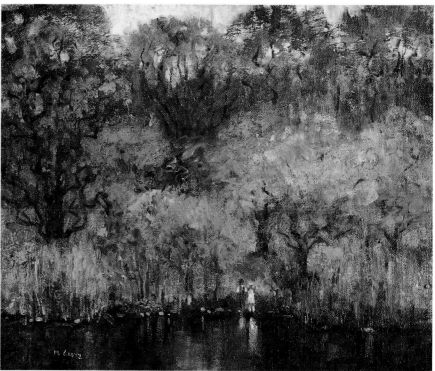

CHILDREN IN CENTRAL PARK
(11x14) Collection of Barbara Tener.
Although the trees did not look as dense as they would have in summer when they're a dark green, even the pond did not provide enough interest beyond the trees themselves. Adding the children gave the painting a human element and a strong focal point. Without the figures the viewer wouldn't know where to look first.

SPRING FLOWERS
(24x18) Collection of Barbara Tener.
This painting, also done in the Brooklyn Botanic Gardens, is an example of handling the intense colors of spring grass and flowering trees. Since I was incorporating this spring lawn *and* all the flowering trees into the composition I softened my palette throughout. The trees do not appear as pink and white as they really were and the lawn is a more muted green.

Morning Glories

(8x10) Collection of
Mr. and Mrs. David Balinsky.
A close-up of blossoms can also make
an effective composition. In this
painting of morning glories I made a
more detailed painting than in the
panoramic garden views. However it
was essential to begin in a loose style
in order to quickly place the morn-
ing glories in the composition. Since
the blossoms last only one day, I had
to decide on an arrangement first
and then use new blooms for models
to finish the painting.

I intentionally arranged the com-
position around the morning glories
themselves, not incorporating sky or
background. This helped accentuate
their striking blue color. This subject
also worked in a close-up because
there was so much variety, with some
blossoms fully open, others wilting,
and still others completely closed.

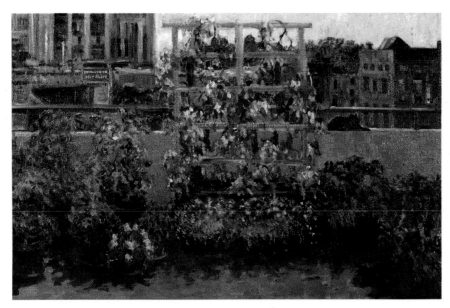

Brooklyn Roof Garden

(16x24) Private collection.
This is an earlier view of the same
scene depicted in *Roof Garden* (see
page 104). The trellis was a real asset
in this composition. With fewer flow-
ers in bloom than in the later paint-
ing, I needed something to enhance
the garden idea. The trellis rose above
the garden wall, obliterating part of
the buildings in the background.
There was still a contrast between
the urban background and garden
setting, with the trellis emphasizing
the garden motif.

Summer Flowers

(30x20) Collection of Barbara Tener.
The Brooklyn Botanic Gardens is also
a good place to paint close-ups of flow-
ers. This painting was done in mid-
summer when many of the flowers were
beginning to fade. There just weren't
enough to make this flower patch
paintable from a distance.

However, including just a portion
of the garden, with the dark trees in
the background, made the subject
more intriguing. A long vertical for-
mat made the composition more appeal-
ing. I worked on a double primed,
coarse weave canvas, which enabled me
to build up lots of texture, lending more
substance to the flowers.

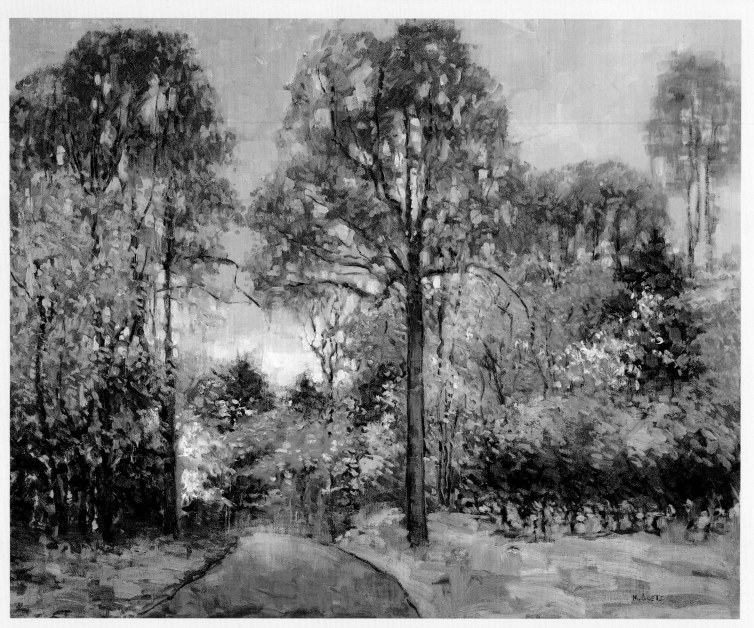

PENN'S WOODS (24x30) Private collection.

COUNTRY SCENES

Having lived in New York City for thirteen years, I always welcome an opportunity to paint in the country. Cities and towns are full of paintable subjects (see the next two chapters), but they are also full of crowds, traffic and general interference. Especially if you are just beginning to paint landscapes, a tranquil country setting might be a better painting location than an urban park in town.

Penn's Woods (facing page) was painted at Washington Crossing State Park in a section that is a wildlife preserve. In this view the woods are interspersed with flowering trees and the sky is bright gray. This is preferable to a spring scene dominated by flowering trees, set against a blue sky—a color combination that is typical of the season but can often appear garish in a painting.

The format is a conventional rectangular size, but the towering trees on either side of the lane gave the composition a more lofty, vertical feeling.

I was fortunate to find a clearing where I could set up some distance from my subject. Often in a park like this everything is so thick with trees it is difficult to step back for a more detached view. The lane in the foreground helped lead the viewer into the painting. Placing a highlight where the lane crests helps keep it from looking too flat.

State parks are great places to paint. They are usually located in a country setting and, though you may encounter an occasional hiker, it is usually possible to find a secluded spot—away from the picnic grounds—where you won't be disturbed. Also, in these parks, you'll often find lakes, ponds, streams or winding trails around which you can design a good composition.

FINDING THE RIGHT SUBJECT

It is a good idea to devote a day exclusively to scouting out painting possibilities in your area. Leave your paint box at home so you'll be forced to concentrate on subject ideas. Do, however, take your viewfinder along so that you'll have an idea what size canvases to bring next time and can work out some compositional ideas before you begin to paint.

When investigating possible subjects, try to find a location with a stream, lake or mountain view—some interesting element to serve as a strong focal point. A view of a dull sky, trees and grass usually isn't very compelling. If you are just beginning to work in landscape, try to find a view with a barn or bridge. Light and shadow patterns are easier to detect in a structure and the barn will give you a clue as to how the light is affecting the foliage. A structure can also provide a simple center of interest.

Deciding which size canvas to use is also important. Format can often transform a simple subject into a far more interesting one. *Picking Flowers* (see page 81) is a good example. On a large canvas the subject took on a splendor that would have been diminished in a smaller painting. Although I had decided ahead of time that the larger format would work best, I brought along several smaller canvases in more conventional rectangular sizes just in case my original idea was too simple for a big painting.

In deciding on a format, your viewfinder is an essential tool. Its main purpose is to help you decide which size canvas works best for the subject you want to paint. Remember, proportions are as important as size in determining which format to use. Breaking away from the standard rectangle or using a double-sized or perhaps a square format can greatly enhance the design of a landscape composition.

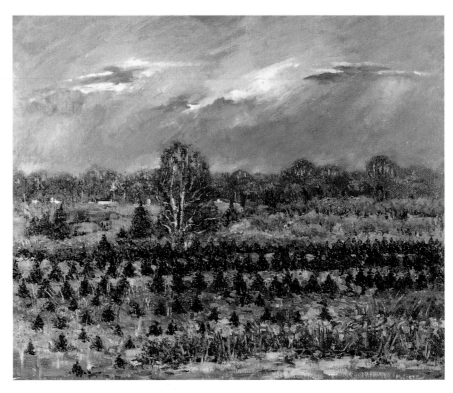

THE NURSERY

(16x20) Courtesy of Grand Central Art Galleries, New York.
This tree nursery in southern Indiana made an unusual subject. However, designing the little pine trees in the foreground was difficult.

The rows of trees in this painting were too uniform, resembling stripes. I therefore eliminated many of them and arranged the trees so there were gaps and variations in the rows. The stormy purple sky added another intriguing element to this composition and helped draw the viewer away from the trees, which could have looked odd and distracting had they dominated the composition.

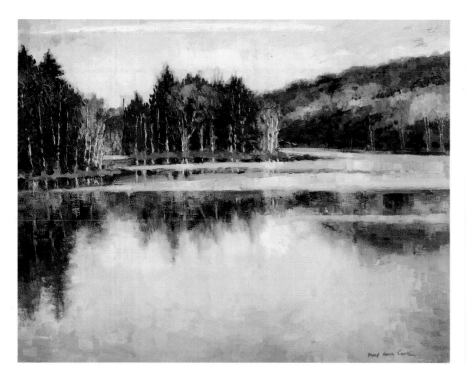

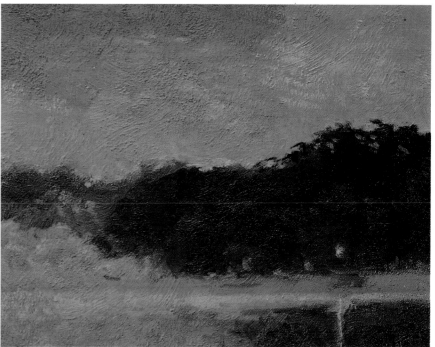

YANKEETOWN POND

(24x30) Courtesy of the James Cox Gallery at Woodstock, New York.
I made the island of trees the focal point in this painting, drawing the viewer into this area via the big expanse of water. The tree trunks catching the late afternoon sun added variety to the clusters of trees, while the broad ripples in the water broke up the repetitious pattern of the trees and reflections. Surrounded by the Catskill mountains, this quiet spot was a perfect place to paint.

EARLY MORNING BIRCH LAKE

(16x20) Collection of Tom Beatty.
Working early in the morning or late in the afternoon when the light is beautiful and fog occurs or shafts of light cut through the clouds can make a simple subject more interesting. In mid-afternoon, this scene did not interest me. However, early on a summer morning the fog, striking cloud patterns, and lights along the shoreline combined to make this a very workable painting idea.

A simple scene can sometimes make a fascinating composition if it is organized properly. Use your viewfinder and experiment with different ideas.

No matter how idyllic the view, it is almost always necessary to take a few liberties with nature in order to make a scene compose well in a painting. More often than not, small changes like re-arranging the placement of the trees or the design of the stream will solve the problem. At other times you will have to investigate until you find a spot where the scenery isn't too dull.

Dense foliage is often a prob-lem. A forest is lovely to stroll through, but stands of thick trees can clutter a composition. Look for a clearing or a lane winding through aisles of trees.

Expansive scenic views can be difficult to compose, too. Often beautiful mountains rise up over dense clusters of trees. Look for a view with a meadow in the fore-ground and mountains in the dis-tance. This arrangement usually reads better in a painting. A meadow in the foreground will also give the viewer the feeling of stepping into the painting.

If you live in an area surround-ed by flat plains, try working on a day when the sky is dramatic.

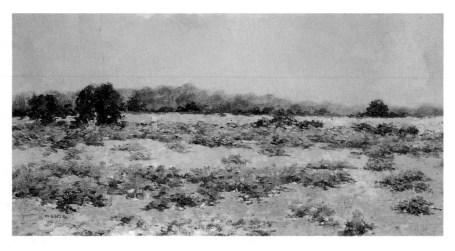

SWAMP GRASS

(15x30) Collection of Barbara Tener.

I drove past this spot many times, because I was attracted to the color of the purple grass. However, I was puzzled as to how I could make this subject more attractive. The grass was a beautiful color, but was surrounded by an ugly swamp. To make matters worse, it was a hot, muggy August and every day the sky was flat and cloudless. A dramatic, stormy sky would have enhanced the appeal of this subject, but the weather didn't cooperate.

By using a double-sized canvas, I was able to eliminate the swamp in the foreground and build my composition around the compelling element—the purple grass. Exaggerating the purple color in the sky resulted in a harmon-ious composition with the sky a paler version of the color of the grass. The entire idea had more impact on an extreme horizontal format.

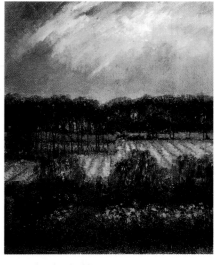

HUNTERDON COUNTY

(20x16)

Autumn's splendor had passed and just a few remnants of all the vivid color remained when this painting was done. At this time of year, when everything appears brown and dead, the painter can view things in an entirely different way.

In this field, the dead trees were a deep rusty color and provided a natural frame for the golden furrows that receded into the middle distance. A surviving patch of green visible through the stand of trees further back provided just enough relief from the abundance of warm foliage.

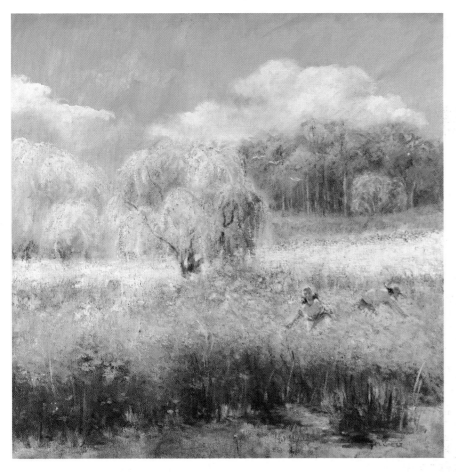

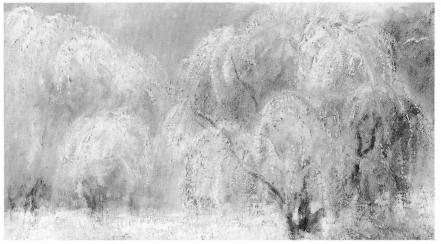

PICKING FLOWERS

(40x39) Collection of Mr. & Mrs. Ben Fishbein.

I hoped that by building up a lot of texture in the fields and trees in this composition, my idea would be substantial enough to work on such a large format. I was also counting on the stunning willow tree and subtle autumn colors to enhance a simple scene. However, as I began to develop the composition, I felt that something was missing, so I worked in the two figures picking flowers.

When painting a view that includes a lot of yellow, avoid a brassy, chrome yellow look. Try mixing some raw umber with yellow.

Detail from PICKING FLOWERS.

When painting willow trees, it is tricky to describe the drooping gesture of the branches. You want to capture the massive shape of the tree, while indicating the frail character of the branches and leaves. Use a thin wash to block in the light and shadow masses in the tree. Drybrush over this initial statement, using an arched stroke that will suggest the gesture of the branches. Finally, build up more texture in the tree and vary the major masses by indicating the delicate yellow leaves.

No Cliché Subjects, Just Cliché Painters

Often painters fall into the trap of settling for a trite composition. Though it is difficult to compose a landscape that is more than a typical depiction of sky, trees and meadows, try to avoid the calendar look—a scene that looks too picture perfect to be real.

Consider arranging a classic scene on an unusual format—a very large, very small or an odd-sized canvas.

If the scene looks like a calendar from a distance, use your viewfinder to extract a more provocative composition using just one section. A dramatic sky or hazy atmosphere can lend an alluring ingredient to a scene that is otherwise trite.

You might also reconsider a location that looked too green and leafy in summer. The addition of subtle autumn color, mountains that were obscured by summer foliage or a patch of spring flowers can enhance a scene much the way a beautiful sky or hazy light can. Snow can also add a new dimension, especially when most of it has melted, creating unusual patterns in the dry winter grass.

PUMPKIN MEADOWS

(16x20) Courtesy of Grand Central Art Galleries, New York.

Finding an unusual or striking subject is a good way to avoid trite results. In this case the groups of pumpkins were obviously what gave this scene personality. There was no time to model each pumpkin at the location. I worked instead on describing the contrast between the bright orange group of pumpkins and the vivid green meadow. Working some yellow pumpkins into the design and indicating a white house in the distance helped break up the mass of orange and green. Back in the studio, I modeled all the pumpkins, referring to a few I developed at the location.

THE GARDEN

(16x26) Collection of Mr. & Mrs. Bill Bently.
This subject would have made a good painting even without the snow. The ochre furrows in the left-hand section of the garden, the dark bushes on the right, and the rose-colored shrubbery along the back made pleasing patterns.

TANNERY BROOK, WOODSTOCK

(30x24) Courtesy of the James Cox Gallery, Woodstock, New York.
The unusual pattern created by the snowy embankment and the brook kept this composition from looking too picturesque. Closing in on the brook and trees, including just a small patch of sky, also helped.

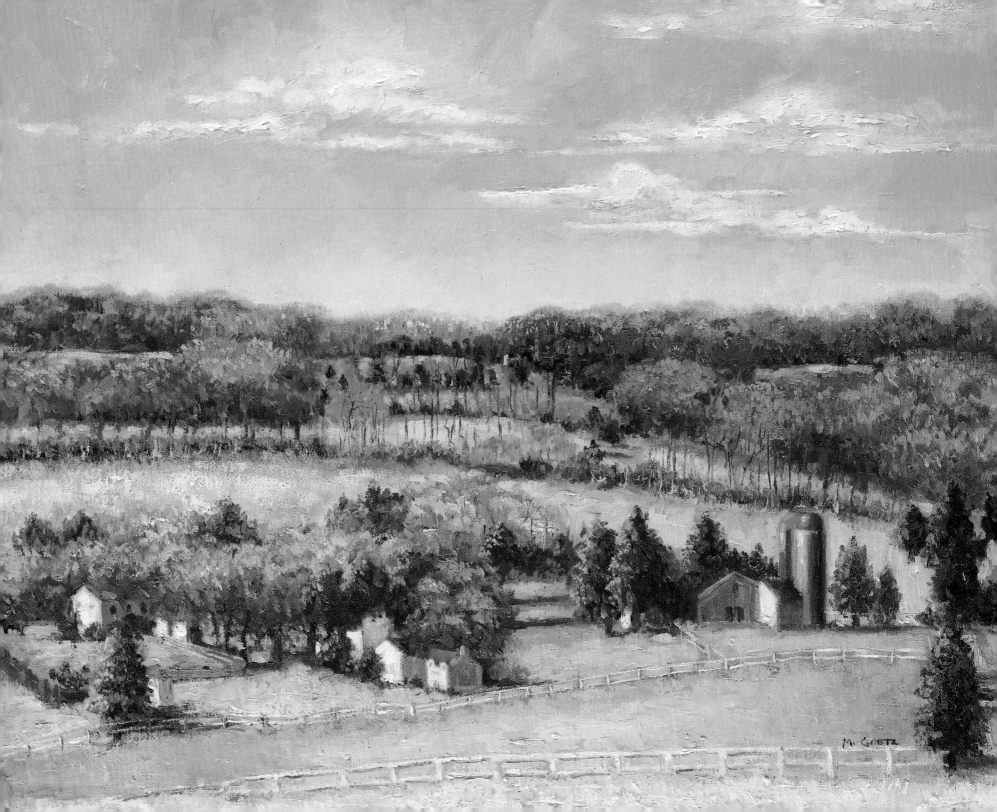

BUCKS COUNTY FARM

(20x24) Collection of Mr. & Mrs. Edward Cerullo.

I painted this scene from a ridge overlooking a big valley. The pattern created by the light sides of the farm buildings catching the winter light helped make this composition more interesting than a vacant pastoral scene.

The cool blue sky balances the otherwise warm palette, while the clouds kept the sky from looking like a flat expanse of blue. I did not describe the whitest portion of the clouds with pure white paint. Against the bright, blue sky, they appeared pink in the lightest portions, with variations of purple and gray in the darker areas. I slightly exaggerated their elongated character to keep the clouds from looking too fluffy.

Detail from BUCKS COUNTY FARM. Patches of grass visible through the trees created a nice pattern in the distance, just as the buildings did in the foreground. Beautiful winter colors of ochre, pink and mauve were also evident in this area.

Detail from BUCKS COUNTY FARM. Notice how the bright buildings add life to this section of the composition. In this detail, you can also see that I built up a lot of texture in this painting, using more pigment where the light caught the sides of the buildings and tops of the trees.

A panoramic view of hills and meadows can make a breathtaking subject. Often wide vistas are found in farming areas where patches of plowed fields cut patterns along the hillsides. Overlapping mountains in the distance change color as they recede, ranging from dark purple to misty blue, creating intriguing passages of cool color.

Making a composition out of all this vast splendor isn't easy, however. Your viewfinder will help. Divide your canvas into horizontal and vertical thirds. (In a very horizontal format you will only need to use vertical divisions.) Now frame your subject with your viewfinder and determine which elements are closest to these reference points. Knowing where to place these elements will give you something to refer to when you arrange the rest of the composition.

A very linear format accentuates the panoramic feeling you are after. The horizontal arrangement also helps you frame the most interesting aspect of a wide open view.

ROLLING HILLS

(30x28) Collection of Union Pacific, Inc, New York.

I had passed this horse farm near my father's home in Bedford Hills, New York, many times and had always wanted to paint it. The problem was avoiding a trite composition. A square format seemed the best solution. By breaking away from the conventional rectangle and giving the sky as much emphasis as the countryside I made a more unusual composition. The hill that rises off to the right kept the painting from looking as if it had been cut in half.

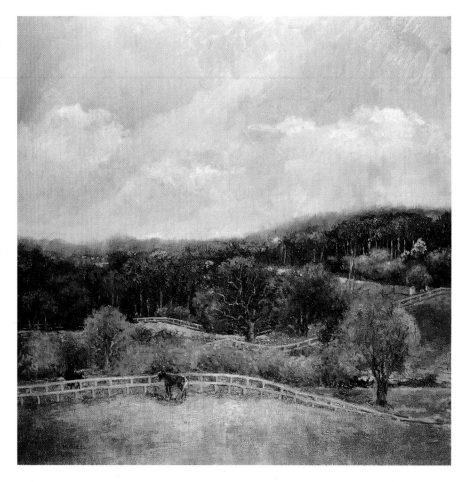

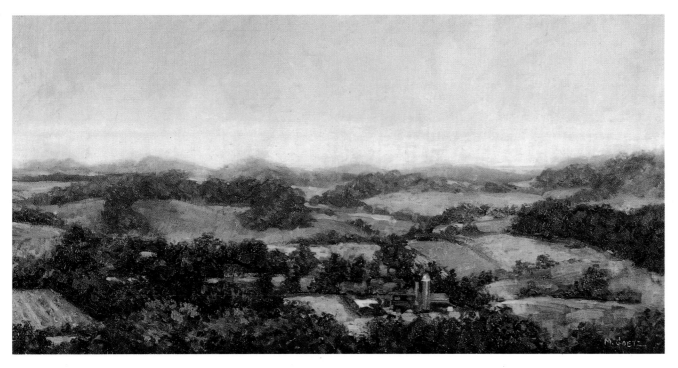

VIEW FROM RADIO HILL TOWER

(16x32) Courtesy of Newman Galleries, Philadelphia.

Plowed fields formed an attractive patchwork quilt pattern in this view of farm country in Sullivan County, New York. A double-sized canvas enabled me to include wide stretches of hills and fields. However, I didn't want the horizontal format to create a composition that was too flat and linear. A glow from the late afternoon sun brought the sky mass forward and added a bright contrasting note to the entire composition, diminishing its horizontal impact.

HORTONVILLE IN AUTUMN

(18x36) Collection of Barbara Tener. Painting on a cloudy afternoon, I was able to accomplish a lot in one outing because the light wasn't constantly changing.

I was careful to rearrange the trees to form a pleasing color balance. Note how the rows of orange trees running diagonally across the painting converge with a group of red trees in the foreground. The dark green foliage that hadn't yet changed color contrasted effectively with the brilliant oranges, reds and yellow. I added white buildings and lightened the tree trunks to keep the warm foliage from looking too dense.

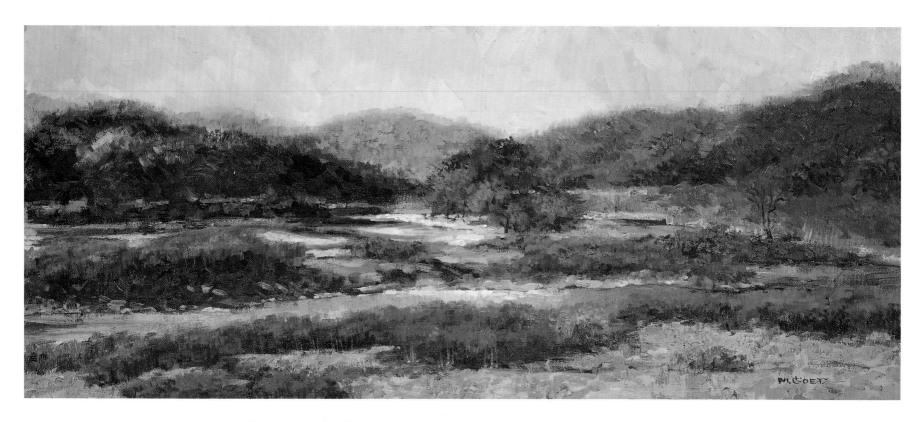

Delaware in Autumn

(14x34) Courtesy of Newman Galleries, Philadelphia.

This painting, unlike many panoramas, included a clearly defined focal point. The eye is drawn to the light striking the water, where the two lines of hills converge diagonally. In a conventional landscape the focal point is right in front of you. In a panorama, much of the action can be to the left or right of your line of vision. This was not the case here.

It was a sunny day, but hazy in the distance, causing the color of the hills to range from dark rust to light blue. This effect created a sense of distance. Unlike many panoramas I have painted, this view was composed at eye level, rather than from an elevated vantage point.

Detail from DELAWARE IN AUTUMN. There are a number of interesting color contrasts in this detail where warm and cool colors play against one another. Notice the diversity created by the bright orange bush and the blue-green grass and the redder shrub and the deep blue water.

SEEING SUBTLE LANDSCAPE COLORS

Describing your subject in terms of big color masses of light and shadow is the basis of good landscape painting. I cannot overemphasize how important it is to study the impact of light on your subject, and to keep things simple.

However, you want to make a painting, not a simple color study. Once you've determined the overall affected color of your subject, analyze each mass carefully. Outdoors, many variations occur, especially in the light masses.

Once you have decided that the affected color of a sunlit grassy area is yellow, study that mass. Are variations of ochre, amber—even blue—also evident? Don't destroy your shadow mass, but try to see variations in color here, too, so the shadows aren't flat or dull.

The key to breaking up big light and shadow masses is subtlety. When refining your first statement with color variations, constantly step back. Make sure your initial statement carries at a distance. It is easy to overdo color changes, losing the transparency in the shadows and creating light masses that are too spotty.

POND IN SPRING
(24x30)

This was a terrific subject. The large tree on the left was just beginning to bud, not yet green. It was raining off and on all day, and the sky was very luminous and silvery, creating a stunning reflection in the pond. The season was late March, still wintry, except for the new grass which was a beautiful bluish green. This area contrasted nicely with the earth color of the still-barren trees and brambles.

The rolling hills and fields in the distance created a contoured pattern in the background. These strips of light mitigated the strong horizontal passages created by the pond and masses of grass in the foreground.

This is a pretty large painting. But working under a shelter used for storing firewood in the winter, I was able to paint for hours and get a good start despite the wet weather.

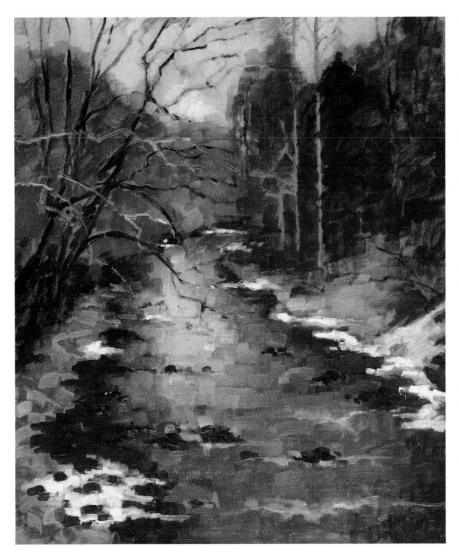

CALICOON CREEK
(24x16)

This view of Calicoon Creek would have been dull and uninteresting without the patches of snow along the embankment. It was a gray, drizzly day and the foliage was dark and dull. Contrasted against the patches of snow, however, the color of the trees and the grass along the bank appeared warmer.

This painting demonstrates how it takes only a little snow to enliven an otherwise dull palette. However, with so few patches of snow set against so much brown earth color it was especially important to create a pleasing design.

Rocks appearing in the middle of the patch of snow in the foreground helped break up this white mass of snow, while fingers of snow protruding into the creek made a nice pattern along shoreline. (I added a bit more snow along the shore than was actually there because I felt it helped the composition.) Finally snow on the bank on the right-hand side of the painting helped balance the composition and carry the eye away from the creek. As you can see, the snow served as a design tool and was the key element in making this idea work.

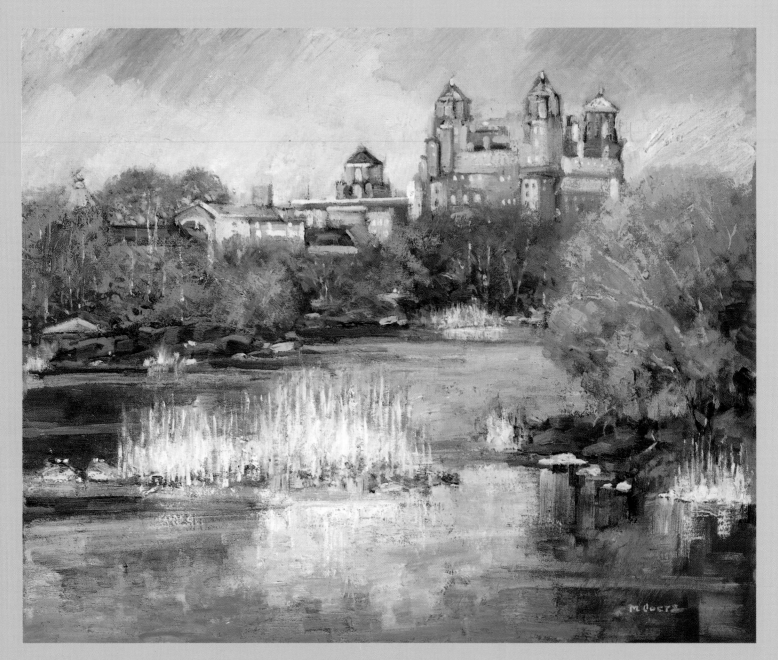

THE LAKE IN CENTRAL PARK (20x24)

BUILDINGS

Including a building or a ribbon of skyline can add so much to an outdoor composition. Placing more emphasis on architecture opens the door to life beyond the landscape.

It is important to understand how architectural elements can add to, rather than overwhelm, your idea. Even if you choose to paint a portion of a building, the light effect and arrangement of the big masses shouldn't be dominated by the subject itself.

If you want to feature a house in a landscape setting, try to avoid a composition that looks like a real estate ad. Either focus on a portion of the house—perhaps including part of the surrounding landscape—or distance yourself so the house is in an expansive landscape setting.

If you are painting city buildings don't feel you have to include every detail. Concentrate on what people would *expect* to see. Place dominant buildings in the skyline as accurately as you can, and indicate the rest. Add ornamental details that identify the building, but don't let details distract you. Think of everything in terms of light, shadow and affected color—just as you would approach a landscape painting.

In *The Lake in Central Park* (facing page) I have used the skyline as more than an added feature in the composition. The Eldorado (the ornate building in the background), set against a pristine blue sky, is an important aspect of the composition. The other buildings rising above the trees also play an important role.

I laid this painting in on a gray day. When I returned, a cloudy morning gave way to blue skies and bright winter sunshine. Rather than start a new painting, I couldn't resist trying to capture the brilliant effect of the buildings shimmering against a cool, blue sky. Since I had worked out all the light and shadow patterns and designed the basic form of the buildings in the grisaille, I could focus all my attention on the effect of crisp winter light shining on the buildings in the background.

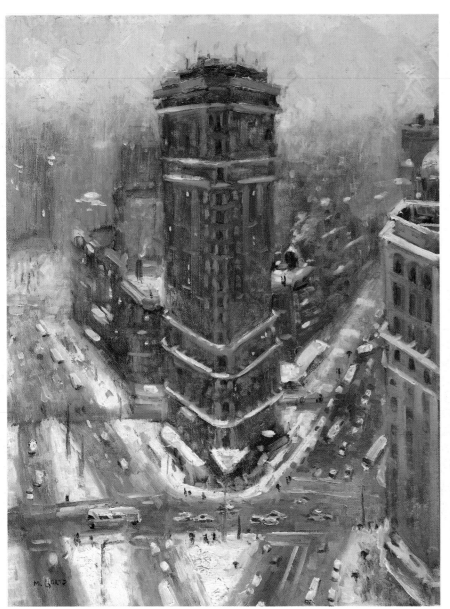

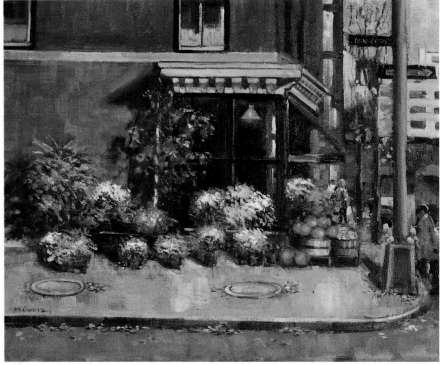

CORNER MARKET IN AUTUMN
(16x20) Courtesy of Grand Central Art Galleries, New York.
The display window is the most attractive part of the building. Adding the yellow hanging light drew attention to the window and the rather nice cornice above it. The flowers and pumpkins were, of course, what really made this idea work.

FLATIRON BUILDING
(22x16) Collection of Mr. & Mrs. Jack Biersworth.
This view of a familiar landmark was spectacular and especially paintable on a snowy morning. I used earth colors to lay in the buildings, added yellow in the snow, and warmed the pale, purplish sky with some yellow ochre to capture the effects of the light and weather conditions.

Details from HALLOWEEN.
The windows were very dark, causing them to jump. To alleviate this, I added a lamp in the downstairs window (detail at left) and a light in an upstairs windows.

To add interest to the steps, I exaggerated the light bouncing off the tops of them and added two pumpkins on the stoop (detail above), using a pair from the house next door as models.

HALLOWEEN

(30x24) Collection of Jack Paramore and Jack Varner.
I liked the effect of the light behind the iron door, but the symmetrical windows and the pattern of the steps and little fence were boring. I positioned the house more on the left side of the picture plane and placed the doorway and fence off center to alleviate the symmetrical look.

SUGGEST, DON'T DESCRIBE

Architectural form and detail make buildings and houses interesting subjects to paint. A church spire silhouetted against a hillside or a pretty doorway in an old house can be the basis for a good composition. However, don't get caught up in detail. Remember that the viewer can be drawn to an illusion of what is there. Rely on the impact of light first and treat the details as icing on the cake.

However, it *is* the ornamental shape of the tower or carving over the doorway—as much as the light effect—that makes an architectural subject interesting. It is important to know when to quit. The artist John Carlson claimed that every student creates a masterpiece, doesn't know it, and then ruins it by working too long. It is easy to think you will improve a subject by adding more details, indicating more bricks, or putting in more curlicues. More often than not, an artful *suggestion* of what is there is all you need.

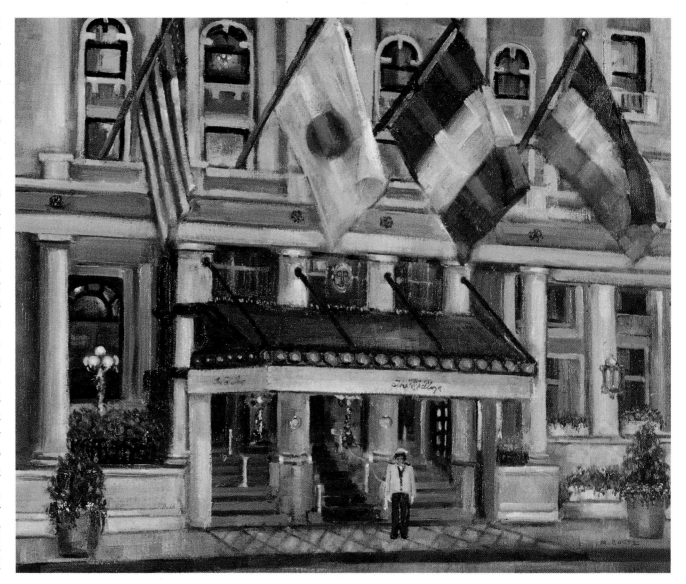

PLAZA HOTEL
(16x20)

In this painting of the Plaza Hotel, I had to decide whether to focus on the entrance of the hotel or to step back and include the flags as well. Both were paintable elements. I decided to include the flags, but didn't want them to overwhelm the ornate entrance. To draw attention to this area I exaggerated the sparkling quality of the brass fixtures. The figure in front also helps pull the flags and entrance together as a center of interest. (Notice that I created the illusion of detail, using just a few strokes.)

Although the flags certainly added interest to this painting, they presented a situation where the subject is changing constantly. I decided to use the flags that were flying the first day I worked at the location, drawing in the entire scene in the grisaille and applying color to all the flags except the American one, which I knew flew daily. Though I didn't change the Japanese flag into a Union Jack, I studied the flags that were flying each day and used that information to make the ones in my painting look more convincing. I paid attention to how they rippled in the wind and the various shapes they created.

CORNER MARKET IN SUMMER
(16x12)

The contrast between the early light bouncing off the flowers and filtering through the trees and the dull, brick store attracted me to this scene. The shadow cast from the eaves and the little tree behind the flowers tie the two areas of the painting together.

The first day I concentrated on the flowers because I knew the display changed daily. I loosely indicated where I wanted to place the flowers, keeping the lay-in simple in case the arrangement on another day appealed to me more.

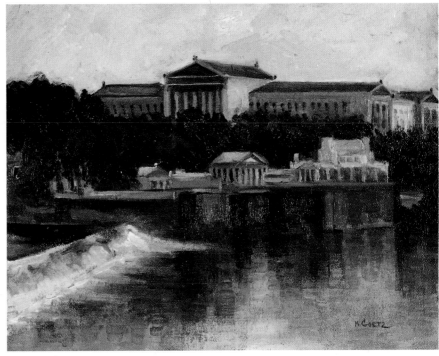

MUSEUM IN EARLY AUTUMN
(20x24)

I featured the river and spillway in this painting of the Philadelphia Museum. The day I painted, the sky was flat and blue and not interesting enough to dominate the composition. I kept the reflections simple, just suggesting them. I felt this made a more interesting idea than mirror-like reflections which would fight with my center of interest.

HAVE SOMETHING TO SAY

If your composition includes a house, barn, or building, try to avoid making an illustration of the architectural element. Composing a house so it dominates everything surrounding it says nothing more than "this is a house." Either treat a building as an aesthetic element in a larger scheme, or zero in on a window, doorway or interesting section.

Placing a building or house right in the middle of the composition with all the steps, doors and windows in perfect symmetry is usually a mistake. To the architect symmetry is crucial, I'm sure. But the artist wants to do more than describe the house. You want an emotional response from your viewer. Compose a section of the house so the symmetry isn't so obvious. Embellish the light effect. Add subtle details that will break up a boring row of windows.

Including patches of snow, fallen leaves or a few well-placed flowers and shrubs can also result in a better aesthetic idea. Don't add a lot of imaginary details, but don't be afraid to embellish what is there either.

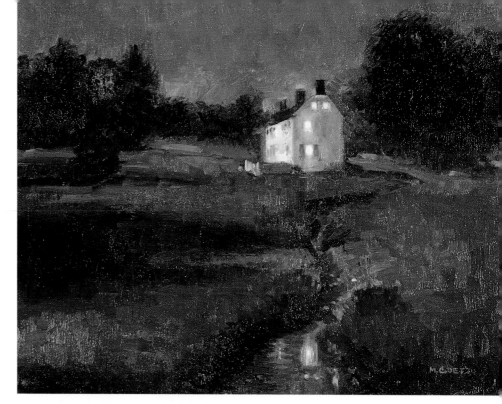

HOUSE NEAR ERWINNA
(11x14) Collection of Mr. and Mrs. Edward Cerullo.
Rather than end up with the real estate ad look, I concentrated on making the house a key element in a rural setting. In order to include the reflection of the interior lights in the gully, I had to position the house in the upper third of the picture plane. Painting the house in bright moonlight with lamps glowing inside created a nocturnal, inviting mood that made this subject more interesting.

Because it was so dark, the color changes in the grass were subtle. Varying the texture of the grass helped break things up without destroying the somber shadow mass.

LOGAN SQUARE
(11x14) Collection of Mrs. Drew Lewis.
Even in the city it is possible to find buildings in an open or landscaped setting. Surrounded by trees and broad walkways, the building is more distinctive than it would have been in a closed-in, urban setting, surrounded by more buildings. I liked the way the building emerged from the background, framed by trees.

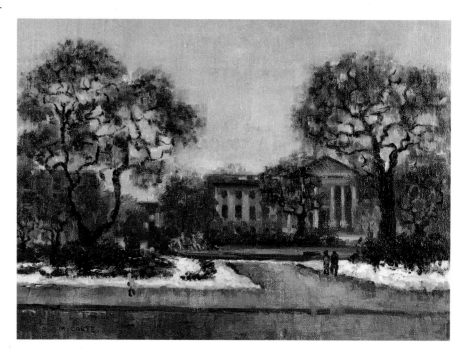

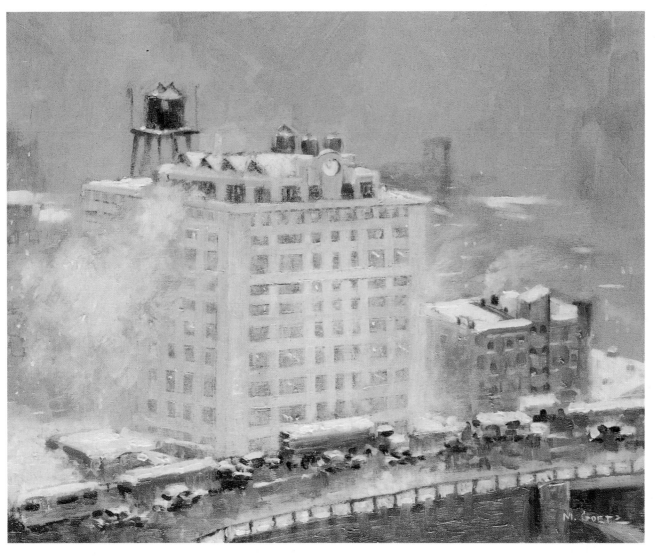

THE GAIR BUILDING

(16x20) Private collection.

On a clear, sunny day I wouldn't have chosen this subject. Without the diffused pink winter light, the Gair Building looks like a big, stiff box full of row upon row of dark windows. It's also surrounded by similar buildings, which were obliterated in the whirling snow. Only a few lights and window ledges were visible. Add the thin screen of smoke and the scene has the ethereal qualities to make a good city painting.

The traffic chugging along the expressway provided some interest and relief from the building's boxy character. However, the windows were repetitious. I scumbled over the building with a mixture of white, raw umber and violet, softening the windows. The addition of small, yellow interior lights also alleviated the monotony.

Remember that windows must be in proper perspective and inserting them in one confident stroke will make it easier to keep the drawing accurate. A stiff, worn, flat brush is ideal for painting windows. The important thing here is control and in this case, a stubby, flat brush is easier to work with than a more flexible one.

AND OTHER ELEMENTS...

Even in a rural setting, including a structure can make the difference between an interesting and a trite composition. A scene that is too green to paint can sometimes work in a composition if an interesting barn or farmhouse is added. A silo that catches the sun can break up a dull cluster of trees behind it. An old farmhouse or white buildings in the distance can add a down-to-earth quality to a saccharin spring painting. Indicating the skyline can lend an interesting urban dimension to a sylvan park scene.

Unless you are focusing on the building itself, don't let a structure dominate the composition. It is important to measure a barn against the hills in the background. The barn will dwarf the landscape surrounding it if it isn't painted in proper proportion to other elements in the composition.

Don't add much detail—especially if a distant building is pictured. Your viewer would not expect to see porch rails and shutters in a distant view of a farmhouse.

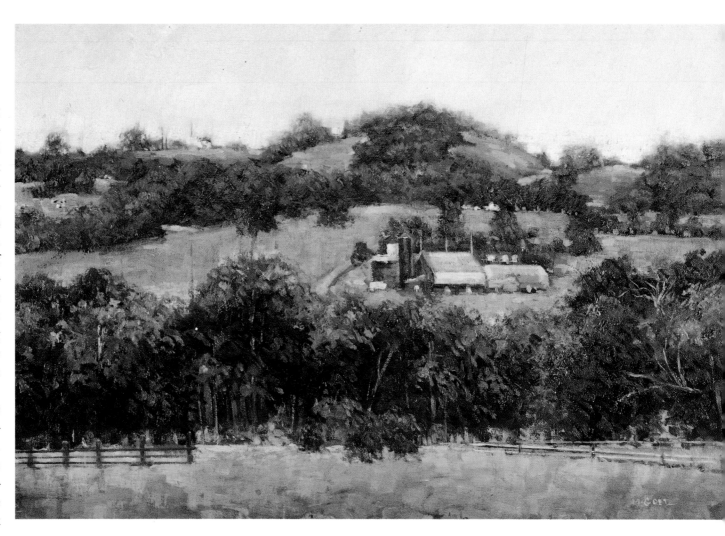

BLUE SILO

(24x30) Courtesy of Newman Galleries, Philadelphia.
Including a barn and silo helped me get a handle on this panoramic view. The rolling hills and valleys seemed to go on forever. The barn provided an anchor around which I could design the expansive landscape. The shiny tin roof of the barn also helped break up the mass of summer foliage.

I was careful to measure the size of the barn against the hills in the distance and the trees in the foreground. Making it too large would have destroyed the panoramic feeling I was after.

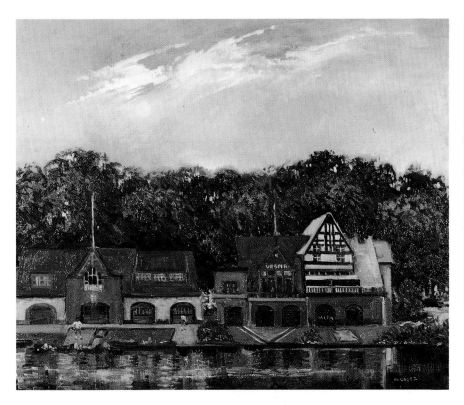

BOATHOUSES ALONG THE SCHUYLKILL

(20x24) Courtesy of Newman Galleries, Philadelphia.

I have painted these sculling boathouses along the Schuylkill River several times because they make such an interesting subject. In the version of this painting at left, I wanted to include the dramatic sky. I now feel that an earlier version (above) was more successful. Adding the sky drew the eye away from the colorful little boathouses and the dark backdrop of trees. The sky also divided the canvas in an awkward way —a big light mass on top and a dark one on the bottom, almost dividing the format in half.

I felt that the streak of water, made when a boat went by, added some more interest to the composition. Using short strokes helped capture the rippled effect of the wake and soften the edges of the reflections.

Roof Garden
(28x32)

The profusion of summer flowers set against an urban background made this a particularly picturesque garden subject. The Watchtower complex where the Jehovah's Witnesses have their headquarters, is pictured in the background, with the traffic moving off of the Brooklyn Bridge. The fact that I was working on hazy, humid days helped soften the stark elements and made the painting look more like a summer theme.

The large mums in the center of the composition were yellow, but leaving them as they actually were made the palette too garish, especially since this large plant was almost in the center of the composition. I painted them white instead, making a more pleasing arrangement.

The detail on the facing page focuses on the background buildings, which looked very bluish in the humid haze. I painted all the buildings first, and then scumbled over them with a mixture of white, violet and a little raw umber using a big bristle brush. This helped make the buildings recede, as the actual color emerged through the distant haze.

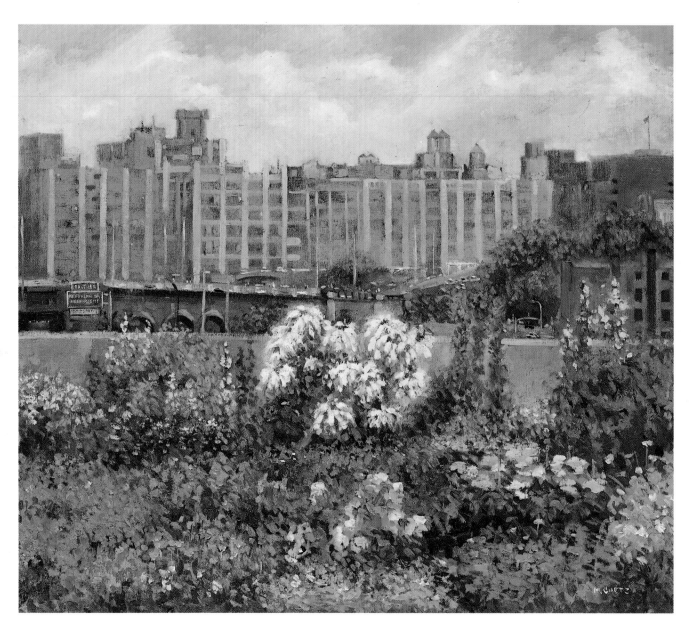

Detail from ROOF GARDEN

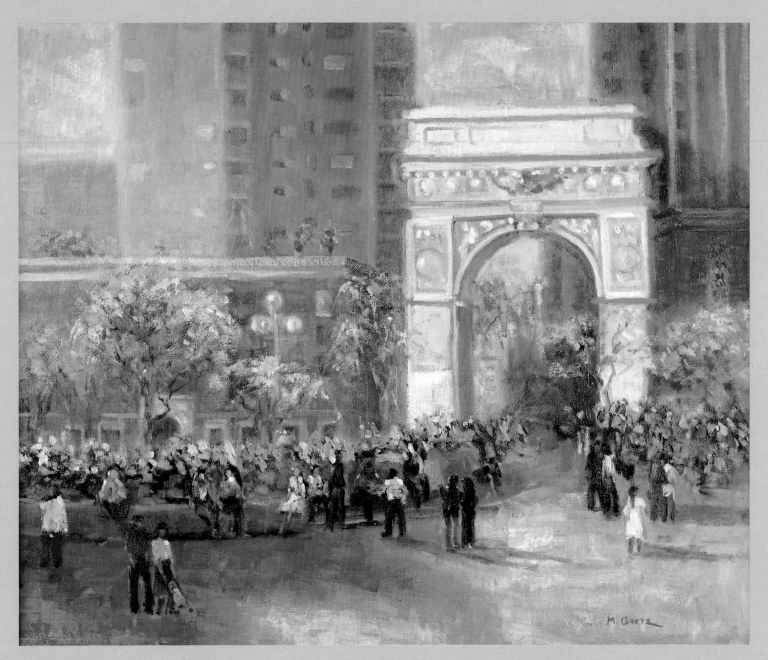

WASHINGTON SQUARE PARK (16x20) Collection of Mr. & Mrs. Ben Fishbein.

CITY AND TOWN

Whether you live in a big city or a small town, the urban scene provides a host of possible painting subjects. From the teeming streets of big cities to the tree-lined avenues of small towns, painting the city is an exciting challenge.

If you draw well and have a good grasp of perspective, don't be afraid to tackle a panoramic city view. Investigate possible painting locations in high rise apartments, buildings or hotels. If you don't feel confident enough to try a complicated urban scene, work in a park, focus on an interesting section of a building or use a fountain as your center of interest.

A street scene depicting throngs of people can also make a good city composition. The painting of *Washington Square Park* (facing page) wouldn't be the same without including the crowds that gather under the beautiful arch at the north end of the park. The figures lent an exciting element to this spring painting.

The arch was the lightest note in the composition, and worked in tandem with the crowd activity to form a strong focal point. The dull modern buildings in the background contrasted effectively with the classic design of the arch.

Although I've massed the figures to suggest a large group, I developed some figures in more detail to help clarify the less-defined ones in the crowd. Interspersing the crowd with figures in light clothing helped break up the density of the crowd and balance the bright arch. I was careful to keep the proportions of the figures accurate. Errors will be noticeable even if the figure is merely suggested.

When painting urban themes it is important not to become overwhelmed. Even a small town or city park will be noisier and more crowded than a rural location. Including buildings, crowds and traffic can be tricky. I hope this chapter provides some helpful information that will encourage you to explore this exciting subject area.

BELVEDERE CASTLE
(20x24)

This "Elizabethan castle" provides a backdrop for the Shakespeare in the Park series in the Delacorte Theatre in Central Park. I eliminated modern pavilions that were added to preserve a period feeling. Belvedere Castle is positioned to break up the overwhelming green in the grass and trees. Because the building looks as if it sprang from the rocks, I broke this mass up with carefully chosen highlights on the light masonry and tiny figures.

CENTRAL PARK IN SPRING
(36x25) Courtesy of Grand Central Art Galleries, New York.

Spring foliage occupies almost two-thirds of this composition. I emphasized the color variations, designed a pattern of the late afternoon light on the treetops, and used different textures to move the eye through the painting. I concentrated the action in the upper portion of the canvas to enhance the vertical quality of the composition, placing the sunlit buildings and the wings of the Metropolitan Museum here.

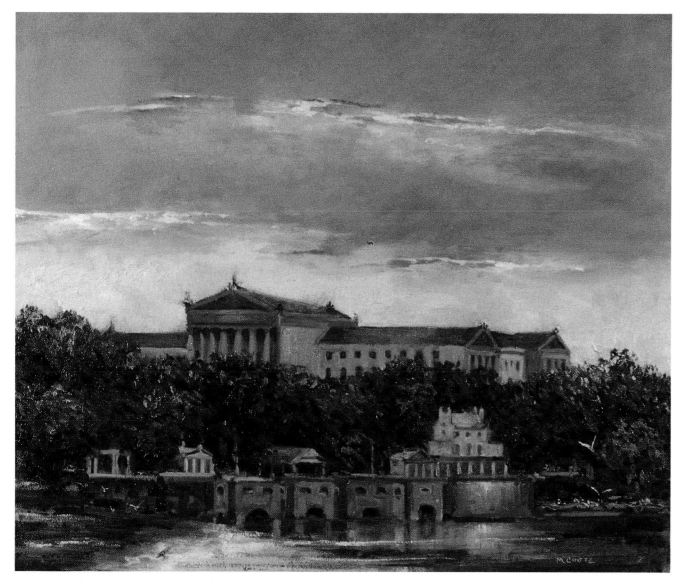

Philadelphia Museum
(20x24) Courtesy of Newman Galleries, Philadelphia.
Here, I featured just enough of the museum to identify it as a public building. The boathouses, the lock and the little buildings above them add an interesting colorful note. (These were wiped out of the grisaille, and laid in a la prima with a small, flat brush.) The landscape plays a major role in the composition: the river has interesting reflected colors, and the sky occupies a large portion of the painting.

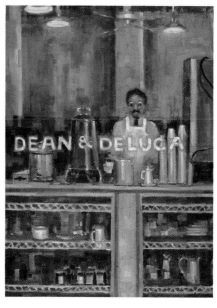

Dean & DeLuca
(21x16)
Store windows often provide interesting ideas for paintings. I originally wanted to paint a display of giant squash in the front windows. But when the squash were replaced with a boring crate of potatoes, I chose to paint the activity inside the store instead. The lettering, the gleaming urn, and the counterman in a white apron made a very interesting subject. Because the man kept moving, I refined the figure whenever he moved into his original position.

What Do I Paint?

Painting urban scenes is generally more difficult than painting a rural landscape. However, all of those challenging elements like buildings and traffic provide a rich source for subject matter.

Particularly on summer afternoons, working in town is often a good alternative to landscape painting. At midday the summer light is less luminous than in the colder months, and summer foliage is often dull and green. Adding an urban ingredient can compensate for the lackluster character of summer light and greenery.

Focusing on an architectural element can produce many good painting ideas. Even if you live in the midst of new homes and shopping malls your town probably has a section with nice old houses, corner markets or beautiful municipal buildings.

Street scenes are another possibility. Set up across the street to take in the sidewalk activity and a section of the block, or work in front of an interesting building, concentrating on the window display.

Parks, of course, are wonderful painting spots. Suggesting a view of the city skyline above the trees or adding a park building can suggest an urban feeling, without involving a lot of perspective problems and complicated details.

Public sculpture and fountains are other good urban subjects. It isn't necessary to take in the entire fountain or monument. A good composition can be built around one sculptural detail or a section of a big monument.

UNION SQUARE
(24x20)

Often a few, well-placed figures can add just the right touch to an urban scene. Here, they help establish the scale of the painting and counteract the massiveness of the statue, foliage and buildings. Although dozens of people were strolling through Union Square, I eliminated most of them, adding just enough to make the composition more interesting.

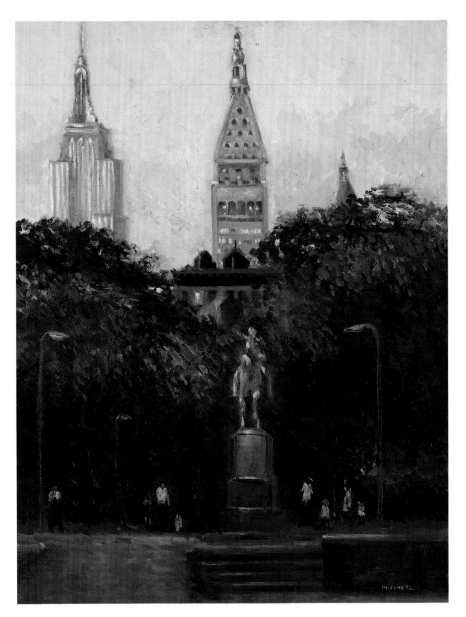

Detail from UNION SQUARE.
I exaggerated the warm color of the late afternoon sky to counteract the cool mass of green trees. The warm sky makes the viewer very aware of the light and shadow areas. Contrasted with the sky, the dark areas under the trees look even darker and cooler. Put your hand over the sky in the reproduction of the entire painting on the previous page to see what a difference it makes.

Detail from UNION SQUARE.
Every figure in the painting is a composite of several people who walked by, because no one was still long enough to serve as a model. I've tried to capture the essence of a person since I couldn't possibly see anyone's facial features from my location across the street. Adding just a dab of paint to indicate a hat or dress or suggesting that one person is black and another white is enough to bring a variety of people to life. Those dabs have to be in proportion to each other, though, or the figures won't look right at all.

When I lived in New York, I often relied on public parks and gardens, especially the Brooklyn Botanic Gardens, for landscape subjects. If you live in a big city or don't have time for a trip to the country, a park is a logical alternative for landscape painting.

Even in a small park, you may be able to devise many compositions from the same spot. Step back and take in a whole patch of flowers, or try a composition focusing on just a few blossoms. Painting a different section of a pond or the same section from another viewpoint can produce two paintings from the same location. Including benches, fountains, or sculpture can also make an interesting concept.

Try working in a city park where the buildings are visible. In *Belmont Plateau*, for example, I've captured a famous view of Philadelphia from Fairmont Park.

Changes in the season and light conditions can also create new subject possibilities. Sections of a park may be too dense and green to paint in summer. Return in November and see if the warm autumn foliage and winter light don't transform the same spot into a subject with fresh possibilities.

Many parks and gardens are replanted as the seasons change, with tulips and iris in spring; geraniums and impatiens in summer; and chrysanthemums in autumn. Each new planting completely changes the appearance of the same flower bed.

Light, of course, makes all the difference. The same garden path will look entirely different dappled with sunlight than on a dark, cloudy day.

One thing to keep in mind when composing a park scene is symmetry. Parks are often designed and plotted so everything is in perfect balance. In a painting, a perfectly symmetrical composition doesn't always work. I usually try to position myself so I'm not looking straight down a garden walk, with identical hedges lined up on each side and a fountain at the end, right in the middle of the composition.

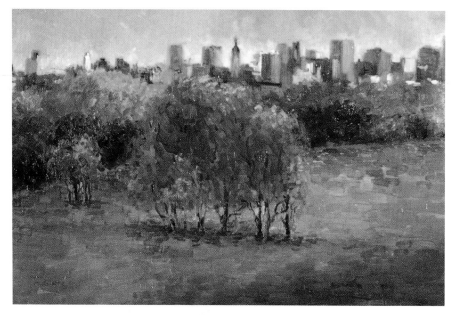

BELMONT PLATEAU

(20x30) Courtesy of Newman Galleries, Philadelphia.

This is the first painting I did in Philadelphia. I didn't have a lot of time, but I wanted to capture a scene that Philadelphians would easily recognize. Standing on Belmont Plateau, I could see downtown Philadelphia rising up behind the trees. In this very famous view of downtown the modern skyscrapers contrasted effectively with the tranquil park setting.

This subject was not too complicated to paint. The buildings are simple shapes and the foliage could be molded into a few large masses. When painting in an unfamiliar place, try a simple idea first, concentrating on the flavor of the place rather than details.

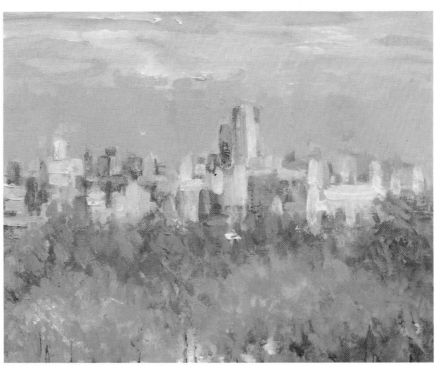

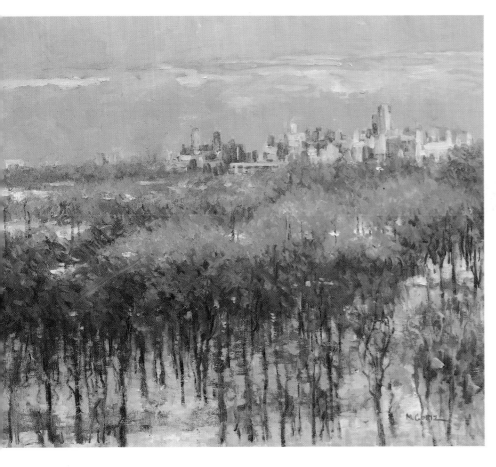

NORTH FROM ESSEX HOUSE

(20x24) Private collection.

While driving down Fifth Avenue in late fall, I saw the Essex House hotel and thought what a wonderful location it would make for painting an aerial view of Central Park in the snow. I promptly made plans to spend a night at the hotel when the first snowfall arrived.

From the large picture window of my eleventh floor room, I chose a view of the northeast section where the warm afternoon light cast an orange glow over the treetops, creating a striking contrast to the snowy ground.

I had to carefully design the tree trunks in the foreground because they were dull and repetitive. I placed some forward and some back, and exaggerated the snowy passages behind the cluster of trees.

Detail from NORTH FROM ESSEX HOUSE.

The late afternoon winter light was especially striking—and important to the success of the painting. I was initially attracted to the warm orange color of the trees and branches and the contrasting cool colors of the snow. I was also delighted when a band of cerulean blue sky appeared through a break in the clouds. I created color accents to break up the mass of yellow and white buildings by exaggerating the shadow patterns.

This is an excellent example of how the contrast between warm and cool colors conveys the effect of light. Although shadows in the trees are warm they appear cool next to the orange in the light mass.

Sculpture and fountains make wonderful subjects. You may want to try some sketches in pencil or oil first, if this is a new subject for you. Especially if you've been doing a lot of landscapes — working with large masses and loose lines—a preliminary sketch will help you with the modeling involved in painting this kind of subject.

Including an entire fountain in your composition will create a scene with lots of action, while a section of glistening fountain makes a different but equally exciting subject. Cascading water can be tricky to paint, especially on a bright, sunny day, when it can appear blindingly white. Use too much white pigment, and the cascade will appear solid. Water is affected by light just as trees and grass are. It may look purple under cool morning light, golden in the afternoon, or hide a rainbow in its spray.

A "waterlike" effect can also be created by working in some of the background color. This will help the water mass look more transparent.

BACCHUS FOUNTAIN
(20x16) Private collection.

A fountain can make an extremely attractive focal point in an urban landscape. The lovely art deco figures and cascading water add to the romantic atmosphere of the scene. There were problems, however. The architectural space around the base of the fountain was flat and boring. Adding a few more fallen leaves than were really there made this portion more interesting without drawing the eye away from the main focal point, the fountain. The similar colors of the trees and the patina on the figures in the fountain created another problem. I alleviated this by exaggerating the blue morning haze in the distance. The contrasting silver-white mass of water also helped keep the composition from looking too green. Though the overall color scheme is cool, the hazy atmosphere softened and warmed the impact of dark green foliage and bright summer light.

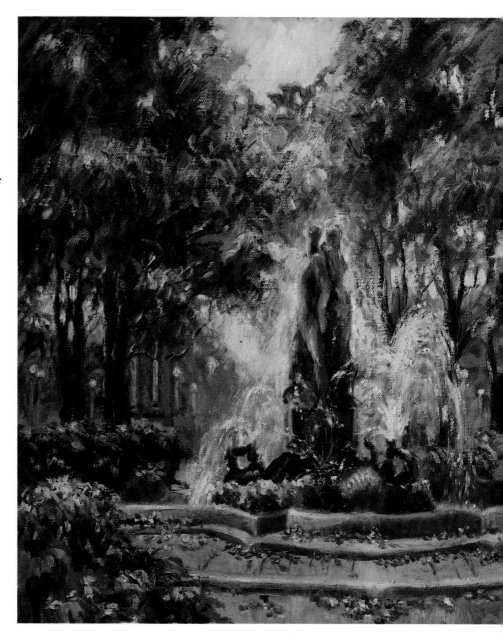

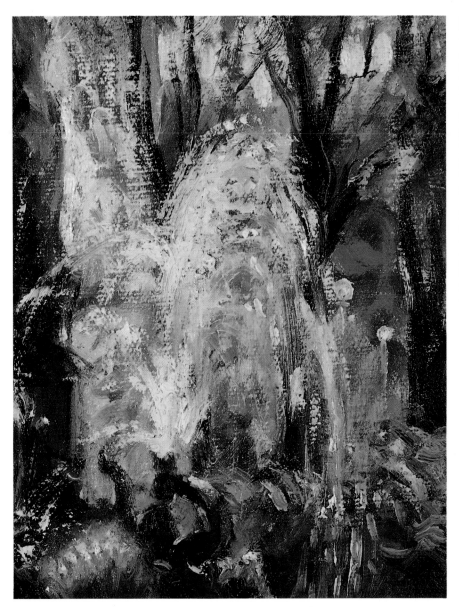

Detail from BACCHUS FOUNTAIN.

Although the use of cool colors adds a hint of mystery and romance to this part of the painting, there are still plenty of warm notes. The highlights and the spots of red on the trees, the streetlights, and the yellow in the grass and foliage keep it from looking too cold. The trees get bluer and lighter as they move into the distant morning haze.

Detail from BACCHUS FOUNTAIN.

I indicated some of the background color behind the water and avoided piling on too much pure white paint. I wiped out the area of the of the spray in the grisaille and then washed it in using thin paint, making the water more opaque where it spurts from the fountain. Indicating a few drops of water splashing against the front of the fountain helped clarify the water mass.

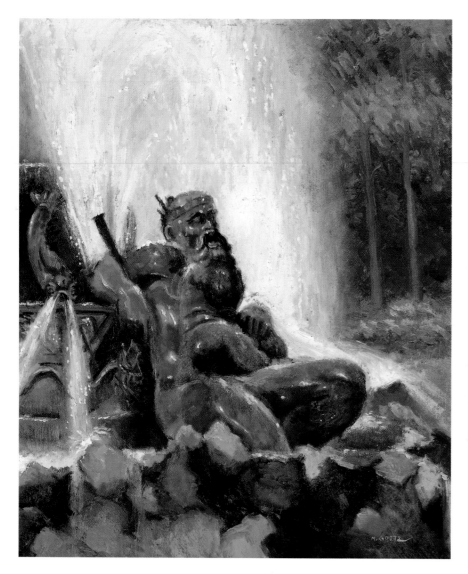

NEPTUNE
(20x16) Collection of Charles Stamps.

This figure of Neptune rests at the base of the Bacchus Fountain shown on page 114. In contrast to the painting of the entire fountain, this painting has a predominantly warm color scheme. The late afternoon light warmed the colors of the fountain and foliage. The close-up focus on the fountain reduces the impact of the foliage and and further warms the scene.

Details from NEPTUNE.

(Above) I pushed the patina of the figure, making it redder than it really is. I exaggerated the gesture so Neptune wouldn't look too stiff. This subject also gave me a perfect opportunity to endow the figure with a little personality. I rendered him almost as if he's singing in the shower, but was careful not make him look too human. (Left) The water appears more solid than it would in a more distant view (the droplets are pure white pigment), but I still lightly indicated the background showing through.

BETHESDA FOUNTAIN

(20x16) Courtesy of the James Cox Gallery, Woodstock, New York. A fountain can make a paintable subject even when the water *isn't* running. In this case, a dry fountain conveys a more wintry feeling—which is what I wanted. I've merely suggested the statue in terms of light and shadow, focusing on the spirit of the place rather than the fountain.

I was attracted to the scene by the contrast between the cool blue of the water and the warm earth colors in the trees. The rose-colored tiles add interest at the bottom of the painting, a counterpoint to the smooth, neutral surface in the bottom of the fountain. I spent a lot of time refining this area of the painting. Subtle color variations like these require careful handling since the values and colors are so close together.

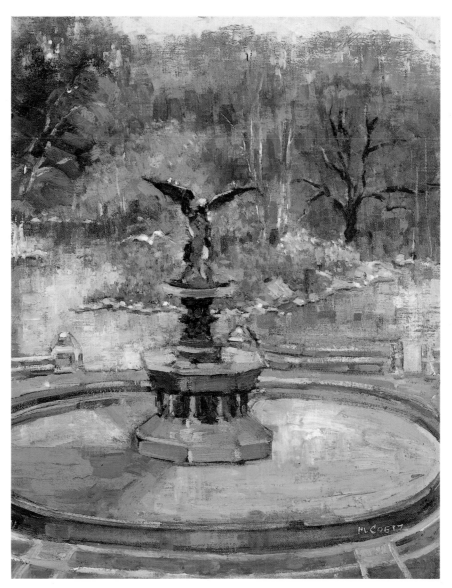

MONUMENT AT COLUMBUS CIRCLE

(12x9)

This was a good figure to use to practice painting public sculpture. It's simple, has a lot of action and, set against the dark green foliage, it was easy to study the basic shape and character of the figure.

I used a smoother technique to paint the figure because it wouldn't look solid if I built up too much texture. Adding more medium and linseed oil to my paint helped achieve this. I laid the painting in *a la prima* and then accentuated highlights.

There are several special elements to be considered when painting in a city or town: buildings, windows, crowds and traffic. In all of these instances, the skillful suggestion of reality can portray more about what is really there than an attempt to include every detail. I would like to emphasize that I am describing my own approach to including these elements in a composition. These are not hard and fast rules. I'm merely sharing ideas that have worked for me as a painter primarily influenced by the Impressionists and their notions about visual painting.

A group of buildings can appear so complicated that it's tempting to give up. The trick is to extract some anchors and reference points to help you get started. Mark off the vertical and horizontal centers of the canvas. Then select familiar landmarks or light-colored or unusual buildings. Place them in the composition as accurately as you can, measuring their distance from these fixed points. By doing this you have something to refer to. Then it's easier to use your eye to determine the placement and proportions of other elements in the composition.

Windows are monotonous, yet when carefully designed, they can lend a wonderfully decorative quality to the composition. Add or subtract windows where it will help the overall design of the painting. Vary the color of the windows, making some dark and others lighter. Drybrush over some windows to make them recede, while refining detail in others to create more realistic effects.

It's often a good idea to include at least a few figures in a street scene. Choose figures in lighter clothing and lay them in first, alleviating the density and providing reference points. Develop detailed figures from people who will remain stationary for a while.

I handle traffic in much the same way I suggested painting windows. Designing car and street lights artistically can lend the same sparkling quality to a composition windows can.

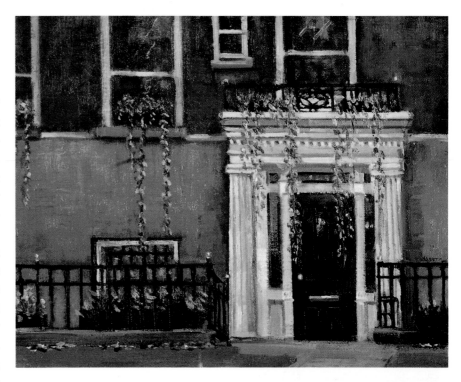

HOUSE ON COLUMBIA HEIGHTS
(11x8)

In this painting, I went a little overboard trying to make an asymmetrical composition. The doorway is the nicest element, and I should have focused more on it instead of placing it entirely in the right-hand side of the format. By cropping the painting just to the left of the small upstairs window (as shown at right), I was able to salvage the painting. The little window supplied just enough relief to keep the composition from being too centered.

NEW YORK GOTHIC

(30x24) Collection of McCarter & English, New Jersey.

I viewed this subject through the window of one of the upper floors of the building across the street. Focusing on just a portion of an ornate building can offer many interesting subjects. Churches and old houses are also adorned with interesting architectural details.

The biggest problem in a painting where the same difficult forms are repeated over and over is keeping all these elements in alignment and creating the illusion that they are identical. At one point I realized I was painting the window on the lower right about a half-inch lower than the one on the left! To avoid getting out of alignment, check your drawing constantly.

It's often difficult to keep other buildings in a scene such as this in the background. Here are some suggestions: Don't add much detail to those buildings and keep the edges soft. Add only a few windows, being careful not to make them too dark. Check your perspective carefully as an error can make everything else look wrong.

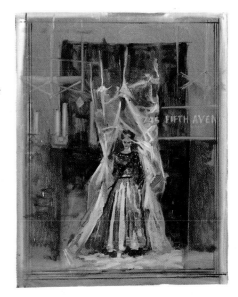

WINDOW AT BERGDORF'S

(30x24)

Modern and old-fashioned storefronts can be fascinating to paint. However, focusing on just the window can result in a painting that looks too much like an illustration of a window display. It would have been better had I stepped back further and perhaps included a portion of an adjacent display window or included a shopper passing by. I left the painting unfinished, almost as a fashion sketch.

If you decide to paint city scenes, take advantage of the host of subject possibilities. Even if you're working in a park, search out a view that will distinguish the scene from a typical landscape.

Finding a good vantage point can be the first step. From a high-rise apartment building in Manhattan, I was able to devise four entirely different compositions—views of the Statue of Liberty (page 10) and Ellis Island (page 16), an industrial scene of the Colgate factory (pictured here), and a painting of the Hoboken Ferry slip (page 68). All were painted from the same window.

Don't reject a possible painting spot just because it doesn't seem ideal. If the view is spectacular, the inconvenience will be worth it. The famous *Flatiron Building* (page 96) was painted from a tiny bathroom window in a mannequin showroom. There was no room to set up my easel, so I propped my canvas on the sink and used it for an easel. The spectacular snowy view more than compensated for the tight working space.

Painting on ground level in the city creates some special problems. Trees planted beside the sidewalk, parked cars and trucks or lampposts can block the doorway or building you want to feature. Look for the same type of subject in a different location where there is no interference.

ACROSS THE HUDSON
(12x9) Private collection.
Several factors combined to make this subject, the Colgate factory in New Jersey, interesting: the vivid red Colgate sign, the bright winter light bouncing off the pale factory buildings, and the puffing smokestacks. I intentionally placed the factory low on the canvas so I could develop the feeling of white smoke and glistening buildings against a bright blue sky. Since this is a small painting, I needed a big sky to keep the buildings from crowding the composition.

HOUSE ON HICKS STREET

(12x9) Collection of Debra Harlan.

I wanted to feature the doorway in this painting. Its striking qualities were most obvious when looking at the door straight on, but a tree was growing right in front of the steps. I had to position myself on the sidewalk across the street to the right of the stoop to come up with a new concept that worked.

HICKS STREET

(18x24) Collection of Mr. & Mrs. Jack Bierswirth.

This is another painting of the house on Hicks Street. When I painted *House on Hicks Street*, the late afternoon sun was shining on the house. In this painting, the early morning sunlight fell on the sidewalk. The flowering tree and patches of sunlight on the sidewalk were key ingredients in making this a successful spring painting.

The sun spots on the sidewalk presented an ever-changing situation. I concentrated on painting them as soon as they began to appear on the sidewalk and worked on other parts of the painting when the sidewalk was sunny or the sun spots were giving way to total shade.

The flowering trees seemed to change almost before my eyes. The solution was to make a decision about how flowery I wanted the tree to be and to stick with that decision. I decided to paint the tree as it was—in full bloom—and once the blossoms began to fall, I worked on other sections of the painting, refining the tree from memory later.

MOTHER'S WAR MEMORIAL

(16x20) Courtesy of Grand Central Art Galleries, New York.

The warm brown foliage was almost the same color as the monument and pavilion. My intention was to feature the contrast between these subdued passages and the luminous late afternoon light on the tree trunks and the figures. The light, rather than the subjects, played the starring role.

There was another set of figures at the other end of the monument, but including both sets of sculpture with a blank wall in between didn't work. It was much more effective to feature just a portion of the wall, using the top of another tree and a few shrubs to pull the less involved portion and the busy side of the composition together.

I exaggerated the variations in and gradation of the colors of the wall to add some interest. Broad vertical and horizontal brushstrokes applied with less paint suggested the texture of the wall.

Detail from MOTHER'S WAR MEMORIAL. I wanted to keep the trees behind the monument warm, without building up too much paint. The limbs were bare and too much texture would have suggested autumn foliage, rather than bare branches. I used a round brush to build up just enough color in the light side to describe this warm passage without destroying its wintry character.

Detail from MOTHER'S WAR MEMORIAL. In painting the sculpture of the mother and child I concentrated on simple light and shadow patterns and included little detail. Overmodeling or adding too many features will make the sculptural element too lifelike.

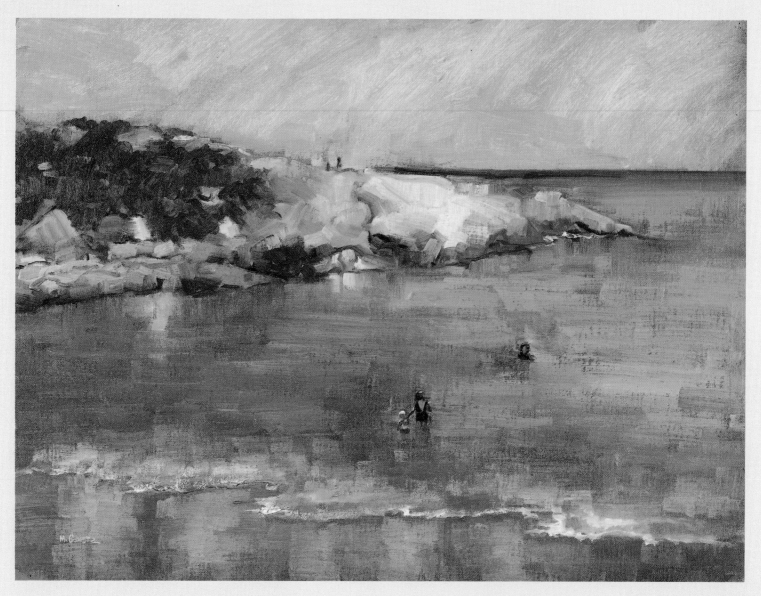

ROCKPORT BEACH (18x24) Courtesy of Grand Central Art Galleries, New York.

Painting on Vacation

Painting an entirely new scene while on vacation or taking a working trip out of town is fun. However, working and traveling is not easy. If you plan to take your paint box along on the family vacation or while traveling with someone else I would first suggest discussing this with your traveling companions. Throwing your equipment in the car and planning to paint when it strikes your fancy can, believe it or not, cause problems for everyone. Will you be staying in a place where there is plenty for you to paint without using a car? If not, you may consider bringing two cars or renting one when you arrive. Otherwise, everyone will be scheduling activities around when and where you have to be dropped off and picked up. Consider beforehand how much time you want to spend painting and how much you want to spend sightseeing and vacationing. Discuss all of this with whomever is traveling with you.

Whether you're vacationing at the seashore or in a cabin in the woods, familiarizing yourself with the lay of the land is the first step toward a successful working vacation. Take as much time as you can afford to scope out the situation and acclimate yourself to the new surroundings.

I recently took an especially productive working trip to Rockport, Massachusetts, and here conditions were ideal. For one thing I was staying with artists, John Terelak and his wife, Pat. I therefore had tour guides who already knew all the best spots to paint. John was also kind enough to let me use his studio (and try his special white paint) when I wasn't working outside.

In the afternoons I painted at the beach in Rockport. As you can see in *Rockport Beach* on the facing page, an ochre-colored rock protruding into the bay made an interesting composition. I worked at low tide when the waves are more gentle and much of the rocky mound was visible. I wanted the rock to be the focal point in the painting and, therefore, subdued the whitecaps, painting them as the tide was receding. In two sessions this painting was almost complete.

PAINTING AT THE BEACH

The biggest problem I've encountered working at the beach is finding a variety of things to paint.

The beach at Cape May, New Jersey, is beautiful, but looking in all directions the scene is very much the same: sand dunes, jetties, sky and ocean. The problem of contending with subject matter that can appear too repetitious applies at the seashore (unless you want to concentrate on crowds).

To come home with a variety of ideas, I concentrated on working at different times of day or cropped the painting so that in one instance the sky dominated, while in another the beach was the main element. I also added details such as figures, beach umbrellas, and a kite.

The same problems can occur in any vacation spot. If you are in the mountains, for example, focus on the forest in one painting; include a big, open sky in another.

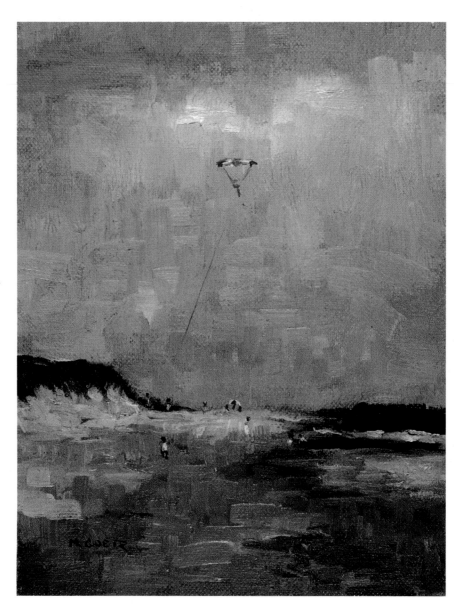

THE KITE

(12x9) Collection of Mr. & Mr. Michael Stelzer.

This painting was done later in the same afternoon I started work on *Crabbing* (on the next page). By this time the stormy clouds had lifted, and my brother-in-law was flying a kite. This gave me an entirely new idea to try without moving my paintbox farther down the beach.

CRABBING

(14x11) Courtesy of Newman Galleries, Philadelphia.

This painting was done on a cloudy afternoon. The sky was silver gray, streaked with darker storm clouds. The linear shape of the clouds worked well, I thought, with the vertical format of the painting, while the characteristic jetties and people gathering crabs on the beach provided a needed element of interest in the lower third of the painting. Often when painting a simple beach scene I will let the sky, if it is particularly dramatic, play the starring role in the composition.

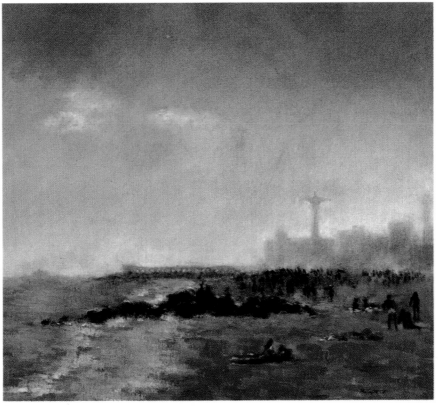

CONEY ISLAND BEACH

(24x30) Collection of Mr. & Mrs. Michael Stelzer.

This painting was done on a hot, sultry day, the sort of conditions that can create beautiful atmospheric effects at the beach.

I set up on the boardwalk opposite the amusement park. From this distance the rides were bathed in a blue haze. They added just the element I needed without drawing attention away from the beach, ocean and sky.

The humid conditions helped subdue the amusement park, giving it a more ethereal feeling and focusing attention on the foreground. The blue background and the ruddy colored beach also made an effective contrast.

Painting in a Foreign Country

Painting in a different country can be inspiring and a great challenge. Just remember that it's not like tossing your equipment in the back of the car and driving to the beach to paint.

The following suggestions might make your painting trip abroad more successful. Bring sets of stretchers and rolled up pieces of precut canvas. This arrangement takes up less space than stretched canvases. Bring only one set of stretchers for each size you want to paint. When rolling up a finished canvas *always* roll it up with the painted side facing *out*. Otherwise it will crack. If the painting is still tacky, lay waxed paper on top of the painted side before rolling it up.

Don't take along big cans of medium and turpentine. Small bottles of turpentine and linseed oil are easier to pack and travel with. Try to estimate how much you'll need and don't bring any more than is necessary. Plan to buy kerosene or household turpentine or paint thinner to clean your brushes when you arrive.

BALI
(24x30)

I had most of the essential information recorded before I left Bali but I did make some changes in the studio. To open up the dense background I added more terraces. I also altered the design of the tree line. The trees actually grew in an even line, leaving an awkward strip of gray sky running along the top of the painting. I feel I made the composition more interesting by creating a "hill" that carried the trees to the upper right-hand edge of the painting.

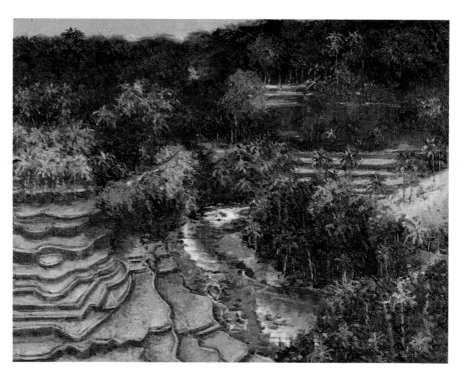

PAINTING IN UBUD

I am working on the grisaille of this subject. You can see how green and panoramic the view is even though only the edge of the ravine is visible here. To deal with the problem of breaking up the dense green color of the rice paddies and foliage, I wiped out a light portion to indicate the stream. This note would provide a focal point without overwhelming the intricate pattern created by the rice paddies.

I don't usually paint while traveling abroad. But if I can spend some time where it is convenient to work, I don't pass up the opportunity. This was the case when my family and I took a trip through Asia. Our first stop was Bali, Indonesia, where we stayed several weeks, affording me plenty of time to paint and still see the beautiful country. I didn't have to venture far to find a paintable subject during our stop in Sanur. The courtyard of our hotel was lush with flowers, palm trees and stone sculpture. While visiting artist Charles Pfahl in Ubud, I painted a ravine terraced with rice paddies and surrounded by tropical plants.

PAINTING VISHNU

Here, I am about to apply color to a small painting of the garden at our hotel in Sanur. I took special care to get an accurate rendering of the hotel roof and balconies in the background. These details would be difficult to refine from memory once I was finishing the painting back in the studio.

VISHNU

(14x11) Collection of Mr. & Mrs. Joseph Pierson.

Here I tried to capture the sparkling, clear light of the Sanur area as it bounced off the mounds of exquisite tropical plants and flowers. I wanted to feature the garden drenched in tropical sun, using the sculpture to break up the foliage and give it a Balinese feeling.

Warming up with a small painting gave me an opportunity to adjust to the new problems painting in this part of the world.

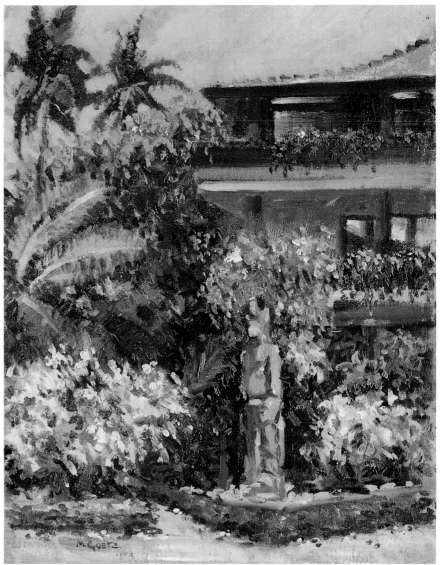

The Working Vacation

I always relish the opportunity to take a working trip—traveling solely for the purpose of painting. Whether it's an overnight or week-long painting trip, consider weather a number-one priority. If you're not prepared for rain, snow or cold, the trip will be much less productive than it could be. Investigate ahead of time so you have an alternative plan if you can't work outside. Are there indoor spots where you can work looking out the window? Would the lobby of the

Banner Hill
(20x24) Courtesy of Grand Central Art Galleries, New York.

The first day I worked only on the grisaille, because it was very time-consuming laying in all the buildings and boats. The following day, I was able to cover the entire painting in color. I later spent several days in the studio building up the paint quality. I didn't apply a lot of paint because I wanted a smoother, more finished surface.

Concentrating too much on texture can alter the color notes in the painting so much you can end up with a different scheme altogether.

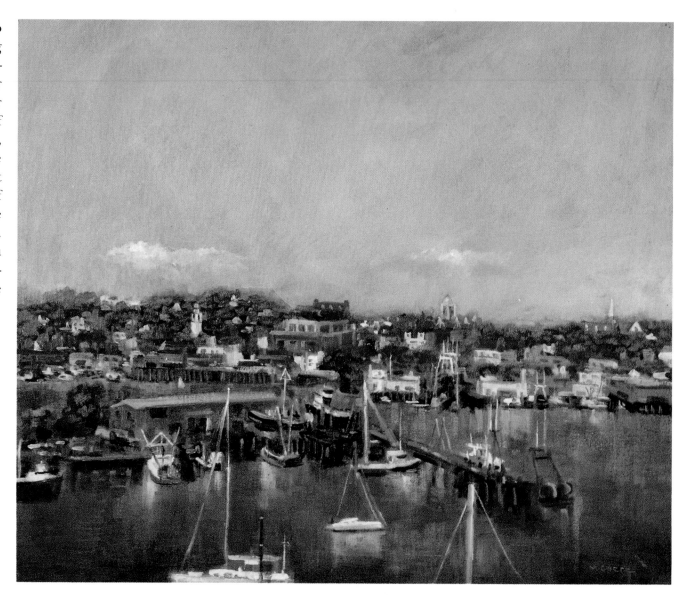

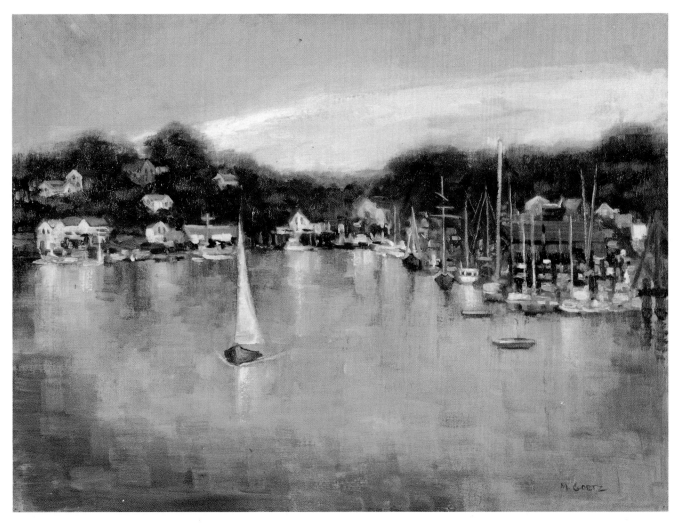

GLOUCESTER HARBOR

(18x24) Courtesy of Grand Central Art Galleries, New York.

Everything was so far away I couldn't devise a composition without using a lot of negative space. The sailboat in the foreground helped. But too much interest was still concentrated in the upper part of the painting. In the studio I modeled the negative space, exaggerating gradations in the value of the water.

hotel or a room in the home you're visiting make a nice interior?

Don't forget any painting supplies and bring plenty of canvases in various sizes. In a new location you won't know what format best suits the subjects available. It's also better to bring too many canvases than to run out with days left in your trip and nothing to paint on.

Visiting friends who live in a paintable area or joining another artist on his own turf can be productive and great fun. Your host will usually find it a special treat to have an artist visit and will often arrange entertainment. Just make it clear that you are anxious to visit but intend to make this a working trip.

Give your hosts plenty of notice and they will often investigate possible places to work. They know the territory and can save you a lot of time looking for good subjects.

My Studio (24x30)

PRACTICAL CONSIDERATIONS

In this chapter, I will discuss some purely practical recommendations for a successful painting excursion. I decided to devote a chapter to this topic because I know artists are developing a growing interest in painting on location. Working "on the spot" is enjoying a comeback. If you want to try *pleine aire* painting, just remember that there are more than aesthetics involved. It won't be as warm (or cool) or comfortable outside as in your own work space. If you forget something, you can't run out and get what you need without tearing down and setting up all over again.

Wind, cold, insects, curious onlookers, rain and snow all make working outdoors difficult. If you're painting in an indoor location away from your studio you'll have to work around someone else's schedule, take precautions not to soil the furniture, or put up with interference from people who live or work there.

However, the inconvenience is worth it. Painting outdoors is exhilarating. I've done some of my best work trying to keep my canvas from blowing away with one hand, while painting the stormy sky with the other. Working fast to record a lot of information before it rains forces me to concentrate on basics and the excitement of the moment. I have often been surprised how successful a start I can get working under challenging conditions. Hassles can be an inspiration rather than a hazard.

Likewise working on a view of the city from a high-rise office or on an interior of a friend's home opens a whole new world of unique subject ideas.

However, sometimes it's impossible to get out . . . or you'd rather stay indoors. In that case you don't have to set up an apple and a jug or paint a vase of flowers. Paint your surroundings instead, as I did when I painted *My Studio* (facing page).

In this painting of my Brooklyn Heights studio, I was trying to eliminate the things one might expect to see in a studio interior—artist, easel, model—and to focus instead on the less romantic elements— the working part. I included a stack of finished paintings, frames, and stretched canvases waiting to be used. I employed a "messy table" theme, covering the taboret with cans of turpentine, medium and used paint rags.

On the shelf the still life objects and art books suggest I might have been fooling around with a new idea, using the art books for reference. The absence of a figure gives the viewers an opportunity to use their own imaginations.

MY EQUIPMENT

Every artist has his or her own favorite equipment. Use whatever you're most comfortable with and what works best for you. I would like, however, to pass along some suggestions based on my experiences painting outdoors.

CANVAS

Once you've mastered the basics of oil painting, it is worth investing in good quality linen canvas. The balance in absorbency and the texture of linen can mean the difference between a professional- and an amateur-looking paint surface. I use Fredrix "Antwerp" linen, which has a medium weave. If I want a smoother texture, I use the single-primed canvas. If I want a crusty surface, I use the double-primed, which is more absorbent and has more tooth, enabling me to build up more paint.

When I'm painting away from home, I always bring at least one extra canvas. I like to stay out long enough to get two starts. It is also good to have a spare canvas in case the weather or light conditions change or to take advantage of special opportunities.

BRUSHES

Since my work is generally loose and painterly, I rarely use sable brushes (although I do have an assortment of small ones I use to paint details and to sign my name). Sable brushes are more suitable for a smoother, more finished technique than mine.

I use both round and flat bristle brushes in sizes ranging from 00 to 9. I am usually inclined to use the flat brushes for laying in a painting as it is easier to cover a big area with a flat brush. They also work beautifully if I want broad and direct brushstrokes—in a big expanse of water, for example. Round brushes are perfect for building up a lot of texture in trees and foliage. I would recommend getting two brushes in each of the smaller sizes, from 00 to 2, as they wear down quickly.

COLORS

I use twenty-one colors on my palette, but I think this may be too many unless you are at a very advanced stage. The essential colors are marked with an asterisk for those who wish to use a more limited palette. My paints are all Winsor & Newton, except for Acra red, Acra violet and Dioxazine purple, which are made by Liquitex. Grumbacher, Winsor & Newton and most major manufacturers of artist paints have a student line that is affordable and includes all the colors you need to start out.

- French ultramarine blue*
- Cobalt blue
- Cerulean blue*
- Viridian
- Yellow green
- Permanent green light*
- Cadmium yellow*
- Lemon yellow
- Indian yellow
- Yellow ochre*
- Cadmium orange*
- Cadmium red*
- Alizarin crimson*
- Permanent rose
- Acra red
- Acra violet
- Dioxazine purple (or a violet)*
- Raw umber*
- Raw sienna*
- Burnt umber*
- Burnt sienna*

I prefer Weber's Permalba white. It has a juicy consistency which makes it possible to use less medium. I prefer to rely on the pigment itself to achieve the results I want and, therefore, also use only a simple medium to mix colors— turpentine and linseed oil—no copal, stand oil or varnish. In my oil cup I mix ten parts turpentine to one part linseed oil.

EASELS

Since I work outside the studio under so many different circumstances I have three different paint boxes: a half-sized French easel box, a full-sized French easel box and a standard paint box which I use with a sketch easel.

Most landscape artists prefer the French easel over using a paint box with a sketch easel. These boxes unfold to provide the artist with a box and easel all in one. The half-sized box is smaller and holds less but can be ideal when carrying equipment some distance or on public transportation.

French easel boxes are expensive. If you plan to do a lot of outdoor painting it is worth investing in a good one as cheaper brands can't take much wear and tear.

THREE ROGUES FROM BROOKLYN

(8x10) Collection of Barbara Schaff. If I hadn't had an extra canvas with me the day I worked at the Mother's War Memorial (see page 122), I wouldn't have captured this wonderful moment. Just as I was finishing work on the memorial, three mongrels strolled up to drink from a flooded area in front of the monument.

I had to work quickly, as the dogs would pause for a drink, then run off to play in the park. I concentrated on the character and gesture of each dog, ignoring detail and painting them almost as silhouettes.

I returned to my studio immediately so I could refine the painting while the image was still fresh in my mind. The dogs themselves needed more definition, as well as the design of the puddle. Though I liked the pale color range, I felt the painting looked too bland without the addition of the green note in the grass.

I didn't add a lot of detail as this would have ruined the light-hearted, spontaneous feeling I wanted.

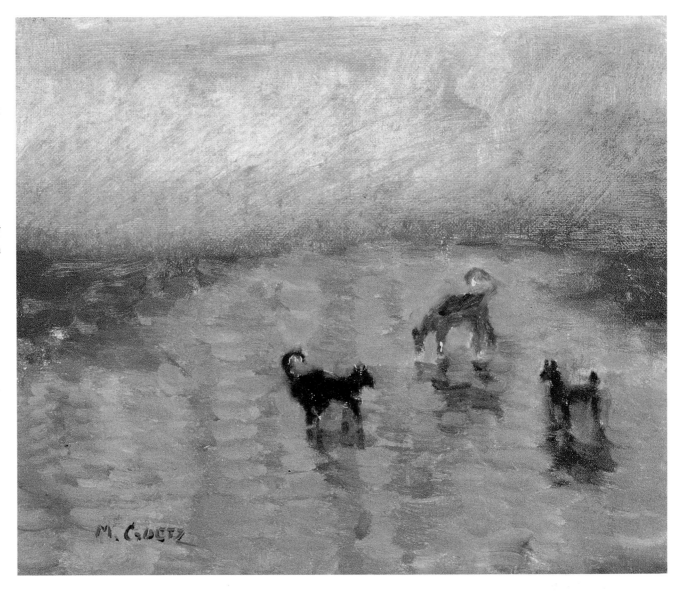

DRESS

Weather is the first thing to consider when deciding what to wear. Check with the national weather service (the phone number for your area is available from information) the day before you plan to paint. Call again in the morning to see if the forecast has changed. Particularly in spring and autumn, temperatures can drop ten to twenty degrees if a cold front moves in. Arriving prepared can mean the difference between a productive outing and being forced to abandon work.

WARM WEATHER

On a hot day, dark clothing is too warm. However, a light-colored shirt will reflect up into the painting, causing a glare. Khaki-colored clothing is perfect for painting in warm weather.

When it is hot, it is tempting to wear as little clothing as possible. However, I think it wise for a female artist to avoid short shorts, halter tops or any clothing that will attract attention. Many times I've heard someone say, "Hey, look at that guy over there." Under these circumstances I don't mind being mistaken for a man. Painting outdoors is difficult enough without inviting distractions.

COLD WEATHER

It is, of course, much easier to dress comfortably in hot weather than in cold. I have found it is too cold to paint more than a half hour or so if the temperature is below thirty-two degrees. (Everyone's tolerance for cold is different, of course.) At thirty-two degrees or above, however, I can work at least an hour and a half if I am properly dressed.

Hands and feet are the biggest problems. Warm, bulky gloves will keep your hands comfortable, but it is impossible to paint with gloves that have no flexibility. I have found that thin wool mittens with fingers work quite well. Buy several cheap pairs. Once the mittens are covered with paint they aren't as flexible as they originally were and it is best to start with a new pair. Even a very neat painter will find that gloves are easily soiled when scraping the palette and wiping off brushes.

Buy the best, warmest boots you can afford for painting outside in cold weather. It is essential that the boots be lined and water resistant. Also wear two or three pairs of wool socks and set up your easel in an area that is as dry as possible.

When painting in cold weather, always wear a warm hat. The knit variety are perfect as they can be worn with a visor. An old down-filled ski jacket is perfect for painting in winter. Be sure to wear warm clothing underneath, too. A flannel shirt and a sweater are perfect. If it warms up you can take your jacket off and still work comfortably.

Dress more warmly than you would to go out walking or for sports activity. Remember, you will be standing still and consequently will feel the cold more.

VARIABLE WEATHER

If you leave on a chilly morning that promises to grow hotter as the day wears on, wear a windbreaker or an old sweatshirt that is lightweight and can be carried home in your backpack or satchel. Take one with you if the opposite situation has been forecast. It's not a bad idea to keep a sweatshirt and a windbreaker in your backpack at all times. That way you won't have to worry.

If rain is predicted, bring an umbrella that is big enough to protect you and your painting. Plastic trash bags can be used to cover your painting and equipment. (Driving to the painting site and finding a nearby parking place is, of course, the ideal situation if you're rained out.)

GENERAL TIPS ABOUT DRESS

• Always wear a sun visor or cap with a bill to block reflected light and to ward off glare.

• Never wear sunglasses when painting. They distort the color of the subject.

• Wear old clothes or a smock, realizing that, even if you are neat, there's a good chance your clothes will be soiled.

• Even in winter, wear clothing that is as lightweight as possible. You will be carrying enough weight around transporting your equipment.

PAINTING IN WINTER

Here I am painting on the Schuylkill River in Philadelphia. The temperature was hovering around thirty-eight degrees and, dressed in a warm hat, an old down jacket over a flannel shirt and sweater, good boots and thin mittens, I was comfortable enough to work for several hours.

You will notice that I found a spot where the snow had melted to set up—much warmer, of course, than standing in the snow itself. Also remember that you will be considerably warmer working in thirty-eight degree weather on a sunny day than on a damp, cloudy day like this one.

Weather

Don't feel you have to wait for perfect weather to work outdoors. You can paint landscapes all year round, if you take the right precautions.

Autumn and spring rains cause problems for many landscape painters. Not only do they interfere with the opportunity to work outdoors, but autumn and spring storms cause the scene to change altogether. A rainy spring day followed by a bright, sunny one forces the trees to suddenly burst into bloom. In autumn, a windy storm can sweep away all the leaves on the trees.

The important thing is to make a decision about whether you want the blossoms or the leaves and stick with it. In a situation where everything changes from day to day, making these changes as they occur will result in an idea far different from the one you originally had and a painting that probably won't hang together very well. If the tree in front of the house looks better now that the tree is in full bloom, go ahead and change it. If that seems to work, stick with

it. The next time you come to work it is very likely the blossoms will be fading, creating a whole new concept. Continuing to alter the tree is confusing. Concentrate on the rest of the painting, and deal with the changing element in the studio. Avoid doing too much work from imagination, however. If you have barely laid in a painting with the trees in bloom and return next time to find the blossoms have all disappeared, it is better to change your original idea. The painting will look too "made up" otherwise.

Rain

If you really want to work from nature on a cloudy day when there's the chance of rain, plan your painting trip with this in mind. The best solution is to set up under a sheltered area. A picnic shelter has often saved a painting outing on a rainy day for me. Shelters are often located in nice parks, surrounded by beautifully landscaped country.

Naturally, trying to find a dry place to work on a rainy day

limits your choice of subjects. It is frustrating to paint outdoors in bad weather. But I feel it is more fun and productive not to be temperamental and to work with what's available.

If there is no sheltered area nearby, keep the following in mind:

- Work on a smaller format (8x10 to 16x20) so you can record a lot of information in a short time in case you get rained out.

- Use lots of medium to lay in the color, so you can cover the canvas faster. If you have captured the light effect and recorded the basic color notes accurately, you can always finish the painting from memory if it continues to rain.

- An umbrella clamped to the side of your easel will help if it is just drizzling. Cover everything that is still exposed with plastic and prop your palette up so that it stays as dry as possible.

- Bring a big plastic trash bag to cover all of your equipment if it starts to pour.

- If you can't avoid getting wet,

it is better to let it rain on the painted side of the canvas (as long as it isn't raining too hard). The oil paint will repel the water (somewhat), whereas, if the back of the canvas gets very wet it will be ruined. I have often walked home several blocks in the rain with my canvas face up. The work I had done streaked somewhat, but in most cases enough of the image survived so that I could continue work on the painting. This is okay for a few blocks in light rain. If it's pouring, run for cover or you'll have a mess on your hands.

Wind

A gusty day can be an exciting time to paint, but it is almost always maddening, especially if the sky is full of clouds. I mentioned earlier that on a windy, cloudy day the clouds will be moving swiftly across the sky causing the sun to peek in and out constantly. These dramatic light changes are difficult to contend with and the clouds are difficult to paint because they are changing all the time.

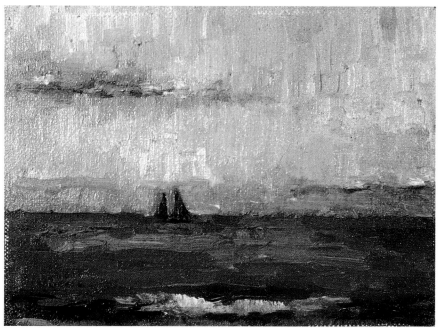

KETCH ON THE DELAWARE

(8x10) Collection of Andrew Newman.

On this windy afternoon I avoided the problems I had painting *Harbor's Mouth* by working on a small canvas. The clamp on my easel was enough to hold the painting steady.

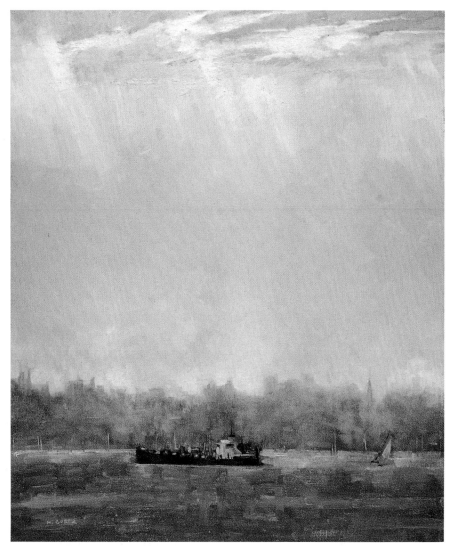

HARBOR'S MOUTH

(24x20) Collection of Mr. & Mrs. John Schaff.

This painting was done on a day that grew very windy. I had known that winds would probably develop while I was out painting, so I brought a brick along with me to keep my box from blowing away. I was fine until the last fifteen minutes. The strong winds caused the canvas to swivel from side to side. I had to hold the painting with one hand and paint with the other!

In a more practical vein, you can't work on a very windy day without anchoring your equipment. I learned this the hard way when I was working on the East River near a heliport, painting the Queensborough Bridge. It was windy to begin with but matters got much worse when a helicopter began to land and zoomed in right over where I was standing. This created such a forceful gust my paint box was swept up in the air and crashed against the sea wall. To avoid having this happen to you on a windy day, a few suggestions might be helpful.

•If you're painting on grass or dirt, stake your paint box down. Use tent stakes on either end of a piece of rope and wrap the rope around the back of your box, anchoring it by putting the stakes in the ground.

•If you're working on a sidewalk or street, of course, the stakes won't work. In this case, weight your box down with a brick, rock, or anything that weighs five to ten pounds. Just place the weight in the back of easel box.

•If you begin work on a calm day and aren't prepared for it suddenly becoming windy, try weighting the box with your backpack. If the bottles of turpentine and medium inside are heavy enough, this can work if it's not too windy.

•A sturdier easel box is much better than a lightweight, half-sized box on a windy day. Even when weighted down, the half-size box is flimsier.

•I prefer to work on canvas because it is lighter to transport. In the wind, however, your canvas will have a tendency to swivel from side to side. A Masonite panel helps alleviate some of these problems. It doesn't have a tendency to swivel in the wind, because it is much heavier than canvas. It will also help weight your equipment down.

•Your palette may also blow away if it's windy enough, so it is therefore better to hold it.

•Any other lightweight equipment you have brought along (paper towels, viewfinder, plastic trash bag) can also blow away. Put what you can in your backpack. I usually put my viewfinder under the leg of my easel box so I have easy access to it.

WORKING INDOORS

If you want to get out of the studio and it's just too hot, windy or rainy to work outdoors, find an indoor location. Paint the snowstorm looking through the window of an office or compose an interior scene of a friend's living room.

Even though you'll be indoors, special considerations apply here, too. Arrange to work when the office or house is empty so you can concentrate and won't be in everyone's way. If this isn't possible, select a spot that is as quiet and out of the way as possible—an empty office or bedroom with a good view.

Be sure to bring a drop-cloth. A big plastic one will protect everything around you and is lightweight and easy to carry.

If you can afford it, the best solution is to rent a hotel room. Just remember that a room with a great view or decor that would make a good interior will probably be expensive.

TRY AN INTERIOR PAINTING

Although I particularly enjoy painting outdoor scenes, interiors are my second love. I often turn to an interior when it is too cold, wet or hot to paint outside. Good indoor subjects are accessible almost anywhere. If you have an interesting or beautiful home, your own surroundings can be an ideal place to paint indoor scenes. A friend's apartment, the lobby of an old hotel or your own studio space are also good possibilities.

If you are beginning to paint interiors, choose a simple subject and work on a small canvas, such as a 12x9. Little interior paintings can be charming and spontaneous and help you get a good feel for this type of subject.

When you're working indoors under natural light the light will change constantly unless all the light is coming from a northern exposure or you're working on a gray day. If the light is changing every few hours, as it does outdoors, work on only one section of the room and when the light changes, try a new angle.

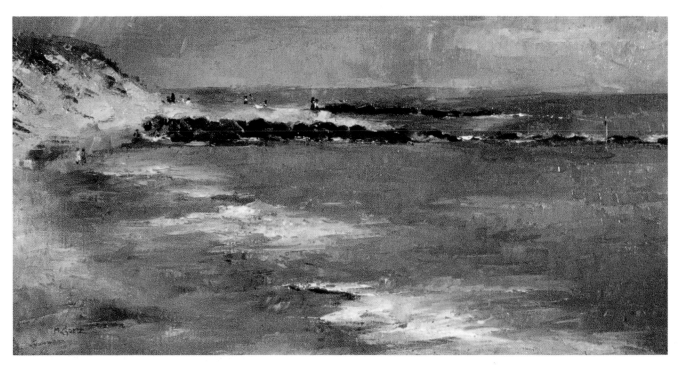

Cape May Jetties

(10x20) Private collection.

On this cloudy afternoon at the beach I knew I might get rained out. I therefore worked on a modest-sized canvas and kept my composition very simple. In the studio I worked with a palette knife to build up a rich paint surface that would compensate for the simplicity of the subject.

At the Location

Working outside the studio, it is important to consider problems that might arise because of the particular spot where you have decided to set up. Having access to a restroom, being bothered by insects, and safety are all things you should think about before setting out on a painting excursion. The following are some things I routinely think about before heading out to paint:

- Are there restrooms nearby? If not, take care of that first and don't plan to work too long!
- Are food and beverages available nearby? If not, bring your own. It is always a good idea to bring a flask or thermos of cold water in warm weather and a thermos of something hot to drink in winter.
- Is the spot where you want to paint possibly unsafe? If so, bring someone along with you.
- Will insects be a problem? If so, arrive prepared with insect repellent and wear long pants and a long-sleeved shirt.
- Will you be standing in the hot sun? If so, bring suntan lotion or work under a tree or shelter.

- Don't set your easel up where you will be asking for trouble—in the middle of the sidewalk or a pathway in a park. Leave plenty of room to get around you.
- Is rain or snow predicted? If so, find a place to paint under a shelter or set up near an area where you can quickly get out of the rain.

When I was painting *Boathouse in Central Park* (see page 12), I set up near a covered snack area because I would be painting on gray days when there is always the chance of rain. The third day I worked on this painting, it began to pour. I had a cup of coffee and waited twenty minutes to see if the rain would let up, but it became clear that we were in for a steady downpour the rest of the afternoon. I covered my painting equipment (easel box and luggage carrier) with a big plastic trash bag and left.

Because the snack area was nearby, I was able to transfer everything to the shelter without folding my easel box up and putting everything away. Had the rain let up, I could have con-

tinued painting without wasting time packing and unpacking.

Additional Considerations

When painting in public parks or gardens, there will be some additional considerations. Investigate the following before you venture out:

- Hours and days that the park or garden is open
- Parking or access to public transportation
- Special permits that might be required
- Restricted areas

Transporting Wet Canvases

Finally, we face the problem of getting your wet paintings home without smearing them or ruining someone else's clothes on the bus or the upholstery in your car.

I have found that plastic spacers (available at most art supply stores) are ideal for carrying two paintings together. They look like thick pushpins, with pins on the top and bottom.

These spacers are also great for carrying paintings home in

the car. If you have gotten paint on the sides of the canvases, mount them together with the spacers and put them in a plastic bag. Most good French easel boxes are equipped with a prong that slides out enabling you to carry two canvases of the same size on your box itself. Be sure that the paintings are mounted with the wet sides facing each other. Even when carrying just one canvas home on your box, mount it so that the wet side is facing in. Otherwise you risk smearing an afternoon's work.

Using spacers, it is also possible to transport two paintings that are different sizes, as long as one of the dimensions is the same—an 18x20 and a 20x24, for example. Just be careful not to smear the portion of the larger canvas that will be exposed.